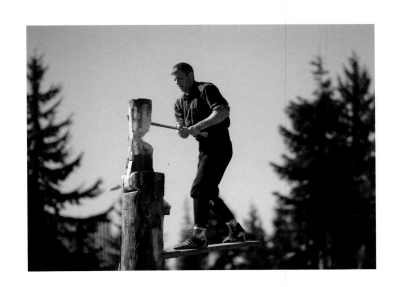

# GROUSE MOUNTAIN

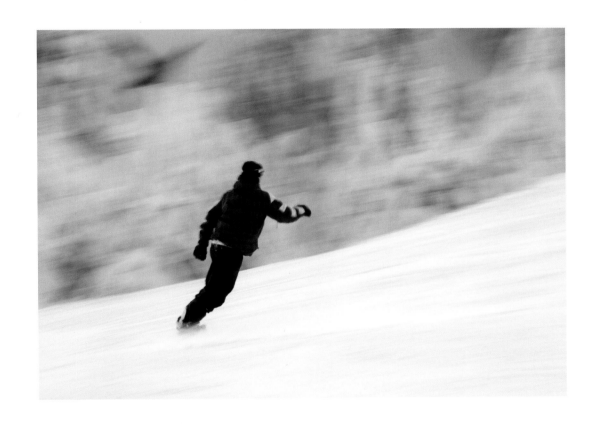

whitecap

The information in this book is true and complete to the best of our knowledge. All
recommendations are made without guarantee on the part of the author or Whitecap Books
Ltd. The author and publisher disclaim any liability in connection with the use
of this information. For additional information please contact Whitecap Books Ltd.,
351 Lynn Avenue, North Vancouver, BC V7J 2C4.

Text by Chris Dagenais
Edited by Nadine Boyd
Proofread by Ben D'Andrea
Cover and interior design by Jesse Marchand and Jacqui Thomas

Printed and bound in Canada

Library and Archives Canada Cataloguing in Publication

Dagenais, Chris
     Grouse Mountain / Chris Dagenais.

ISBN 1-55285-861-8
ISBN 978-1-55285-861-5

     1. Grouse Mountain Region (B.C.)--Guidebooks.  2. Grouse Mountain
Region (B.C.)--Pictorial works.  I. Title.

FC3845.G76D34 2007          917.11'33045          C2006-904987-4

The publisher acknowledges the support of the Government of Canada through the Book
Publishing Industry Development Program (BPIDP) and the Province of British Columbia
through the Book Publishing Tax Credit.

Grouse Mountain towers proudly some 4,000 feet above Vancouver, painting the city skyline in seasonal hues of green and silver. For over a century, the alpine resort has drawn visitors from down the road to half way around the world, the combined promise of unspoiled nature and sophisticated recreation proving too difficult to resist.

Situated only 15 minutes from the downtown core of Vancouver, Grouse Mountain is the perfect union of wilderness and civilization, uniting the best elements of a vibrant city with the grandeur of its distinctly British Columbia geography.

Over the decades the resort has inspired novel undertakings, from a planned railway to the summit in the 1920s to North America's first double chairlift in 1945. Whatever the initiative, the goal was always the same: to get to the top! It was in 1966 that the original Blue Skyride was installed, bringing unprecedented speed, convenience, and excitement to the ascent of the mountain. A decade later, the Red Skyride was installed, completing the continent's largest aerial tram system.

Today, under the private local ownership of the McLaughlin family, Grouse Mountain has the honor of being Vancouver's most visited four-season attraction, offering a dynamic array of activities for all ages. From the best in North Shore skiing and snowboarding to award-winning dining in the Peak Chalet, from panoramic views of the Lower Mainland to breathtaking wildlife encounters, Grouse Mountain truly is The Peak of Vancouver.

Included here are eight exclusive recipes from The Observatory restaurant. These tantalizing dishes are presented step by step so that you can bring the flavours of the mountain restaurant to your own kitchen.

This book shows how the mountain has captured the hearts and minds of millions of visitors. The uninitiated to the beauty of the Pacific Northwest will be inspired by the images in this book. For those familiar with this magical region, we hope these pages conjure fond remembrances of one of the great places on earth.

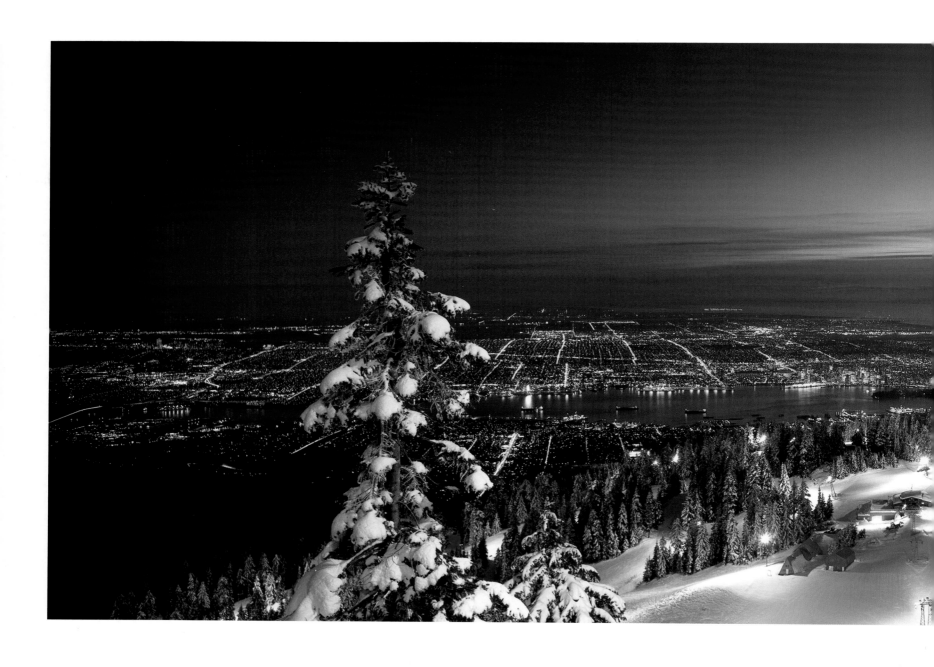

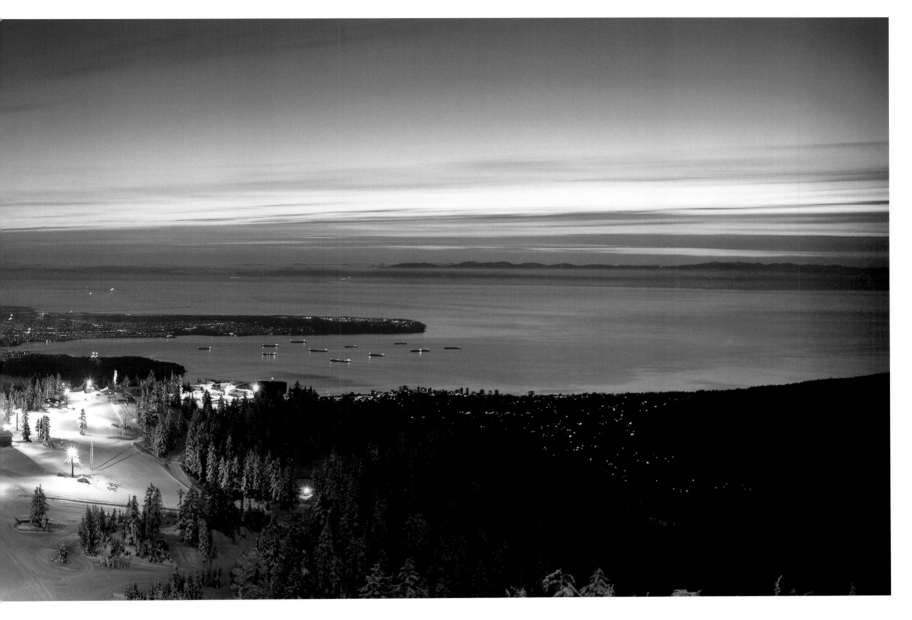

Located just 15 minutes north of downtown Vancouver, Grouse Mountain is one of the most easily accessible ski and snowboard destinations in the world.

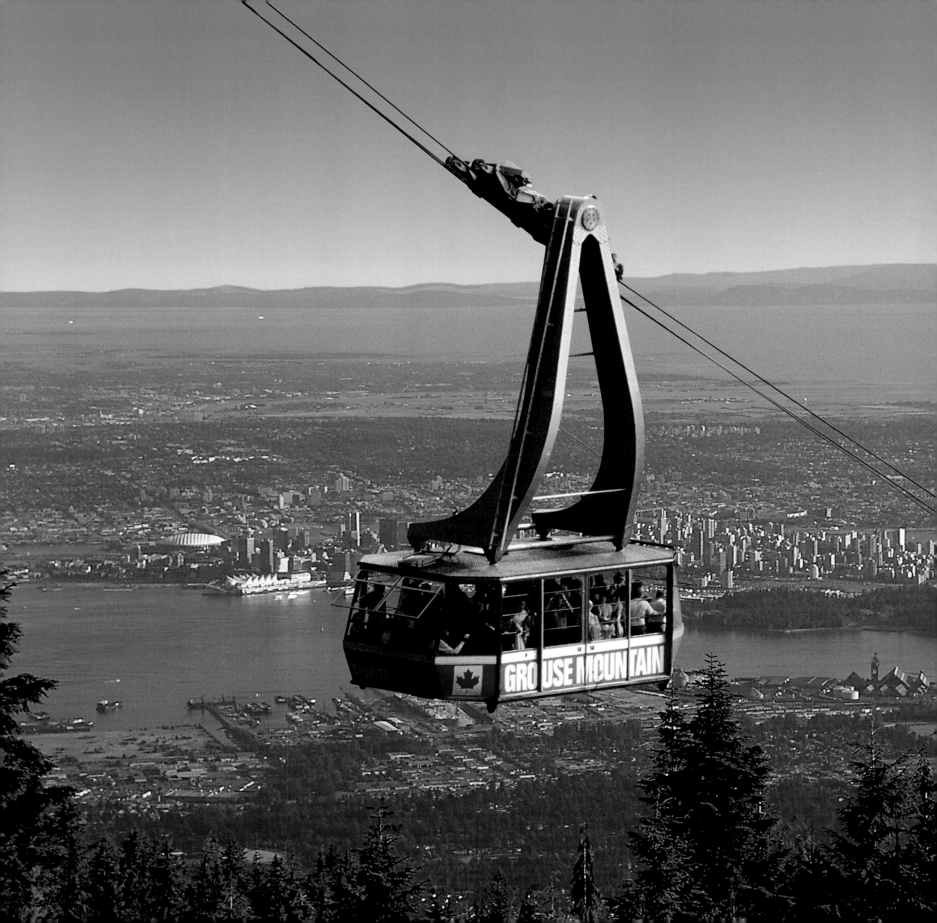

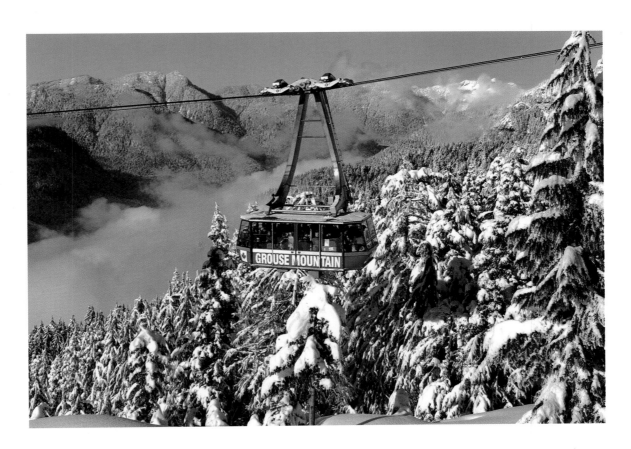

In Garaventa's reversible aerial tramway system, two passenger cars each travel on their own dedicated pathway, simply reversing direction for the return trip. The Red Skyride has become an internationally recognized icon for tourism and recreation in Vancouver, appearing in thousands of publications, films, television specials, and commercial productions.

In 1976 Grouse Mountain changed the face of tourism by adding The Red Skyride to its aerial tram system. The tram spans a distance of over one mile and gains 2,800 feet in elevation along the way.

Each of the two 100-person capacity Red Skyride cars is attached to the same cable, so that uphill and downhill passengers travel at exactly the same speed. It is a common optical illusion for uphill passengers to perceive the downhill car moving faster!

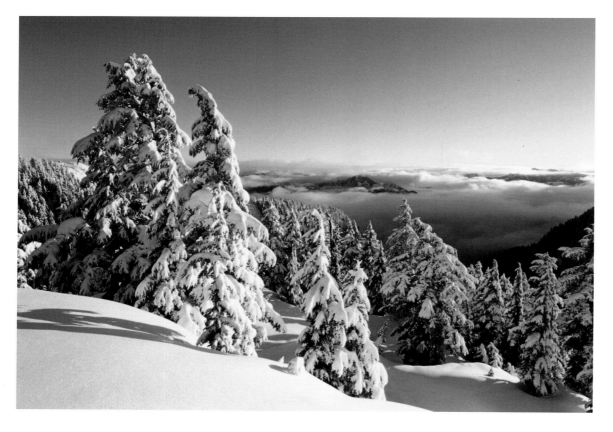

In November 2006, Grouse Mountain celebrated the launch of its 80th winter season as Vancouver's backyard playground.

Skiers and snowboarders enjoy the diversity of Grouse Mountain's terrain—from the ultimate learning ground, Paradise Bowl, to the adrenaline-driving vertical of black diamond runs like Purgatory and Inferno.

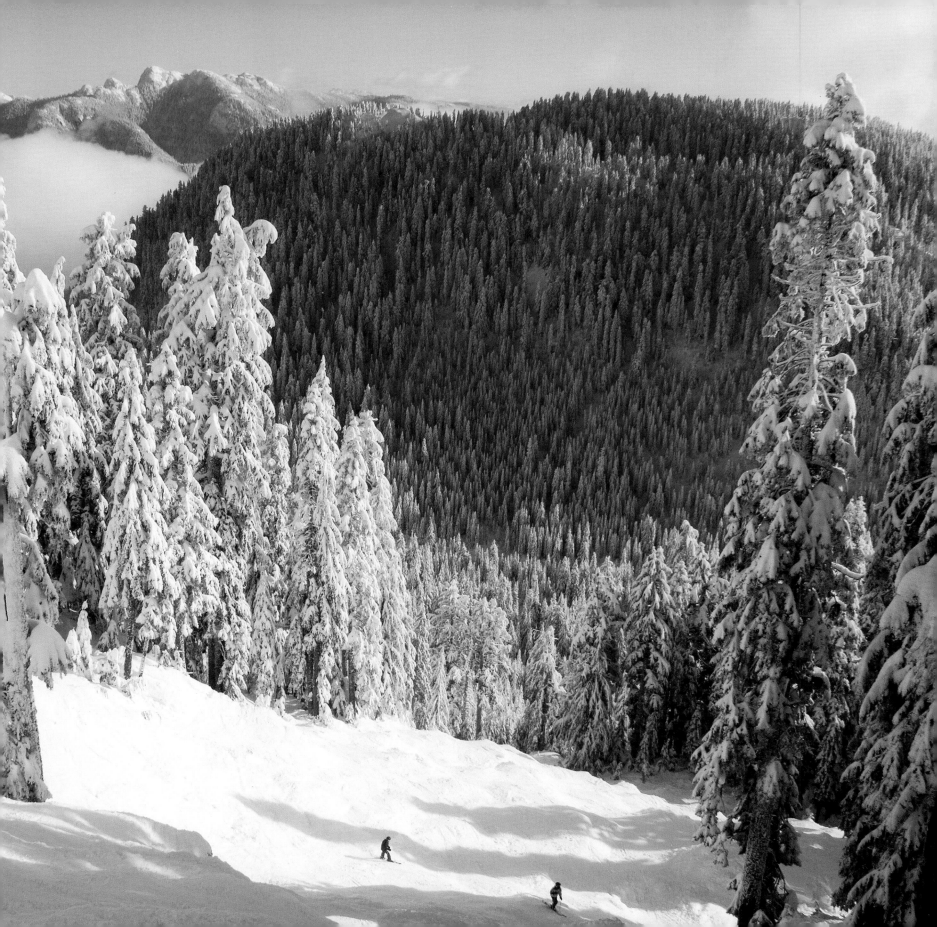

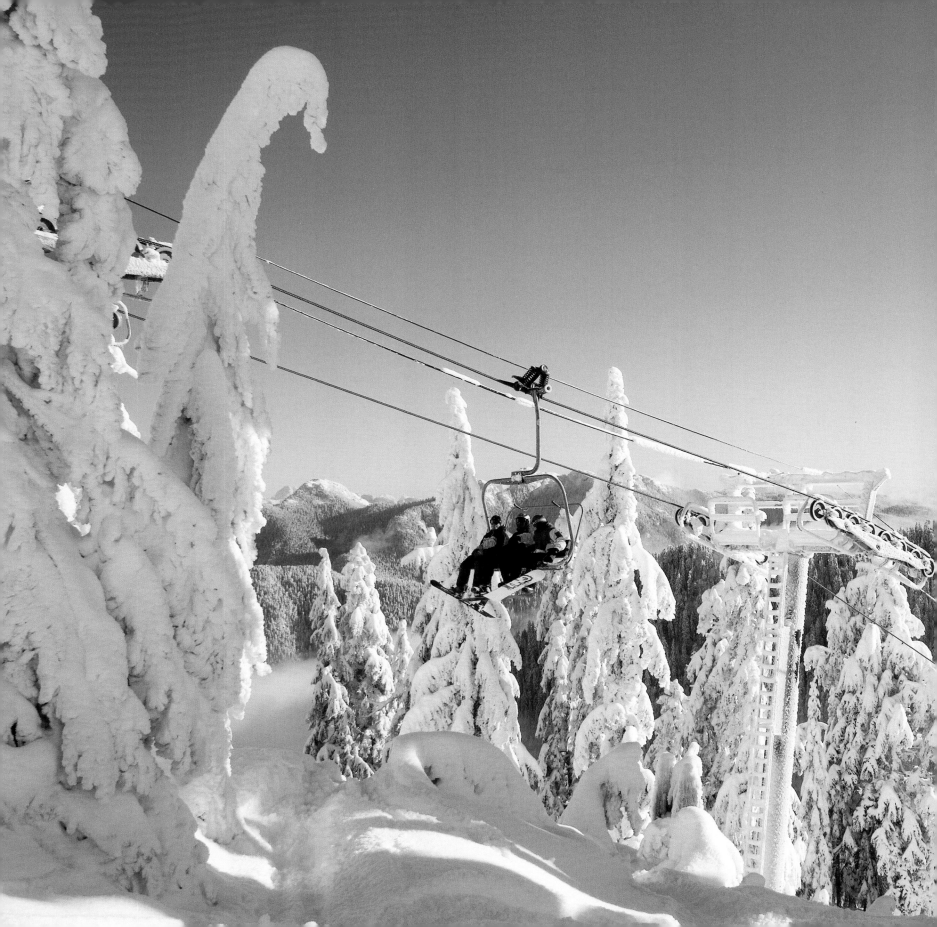

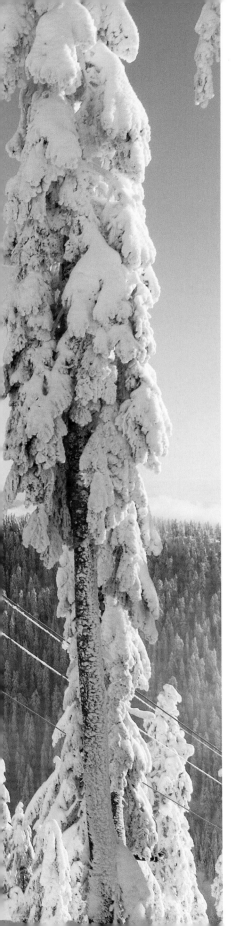

Grouse Mountain is home to Vancouver's first high-speed detachable quad chairlift, The Screaming Eagle. The Eagle can transport guests 5.08 metres per second.

The Olympic Express Chair embodies Grouse Mountain's commitment to promoting winter sports over the better part of a century. *(left)*

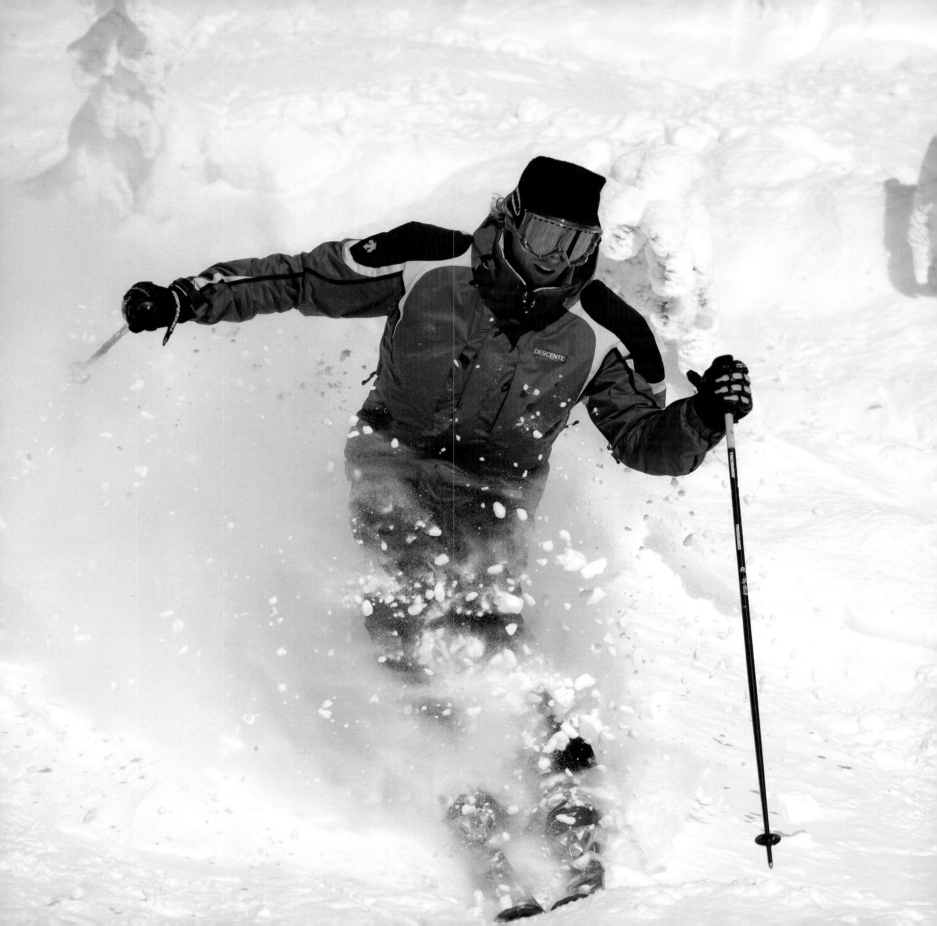

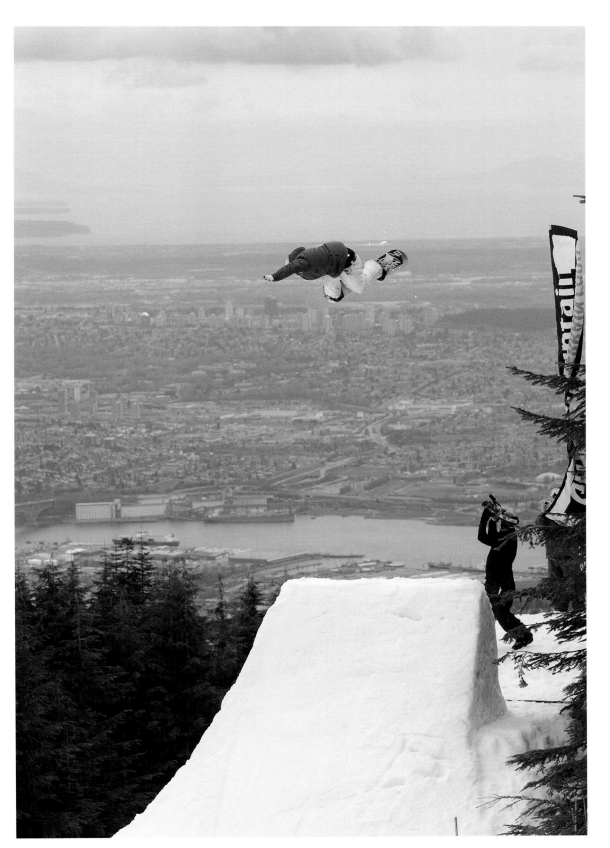

Some of the world's best riders call Grouse Mountain home. The resort's Pro Team represents the top of the sport and can often be found carving alongside other riders in the famed parks of Side Cut.

Fresh, deep powder draws early risers eager to make the day's first tracks.
*(far left)*

15

The Advanced Terrain Park hosts some of Vancouver's top competitive snowboarding competitions and prompts elite athletes to take their game to a new level.

Grouse Mountain Park Zones offer freestylers the chance to navigate some of the most creative and cutting-edge features anywhere. *(far right)*

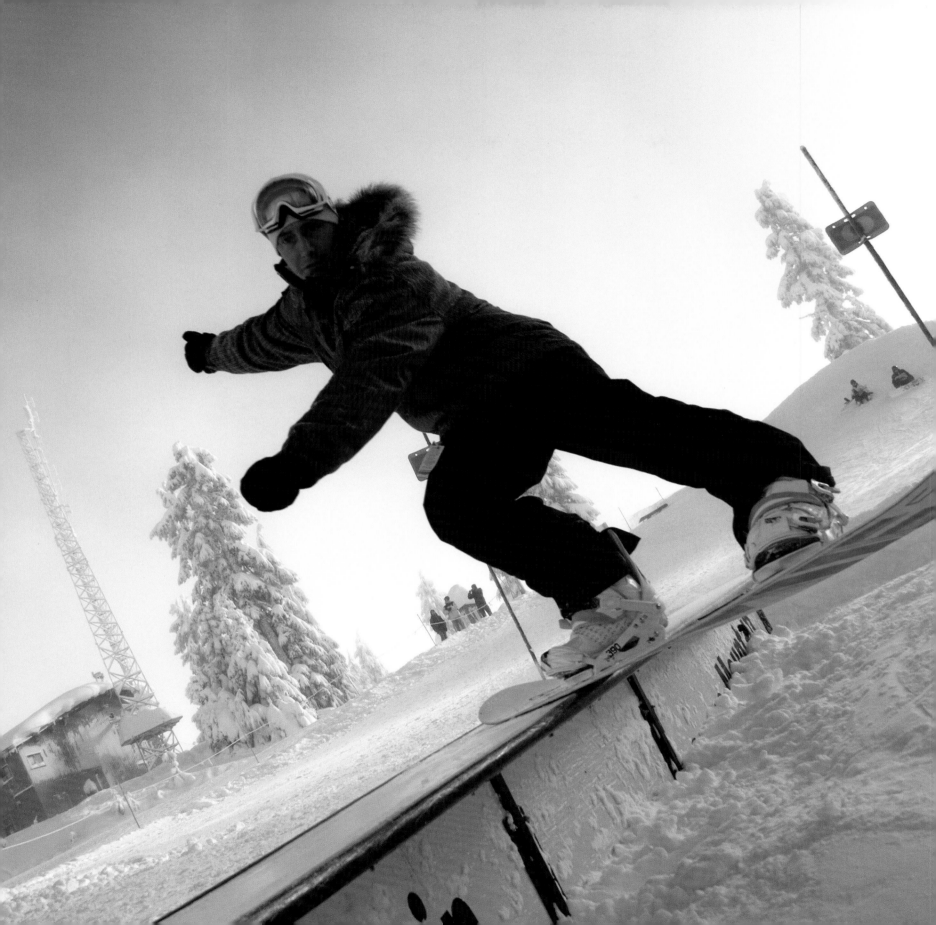

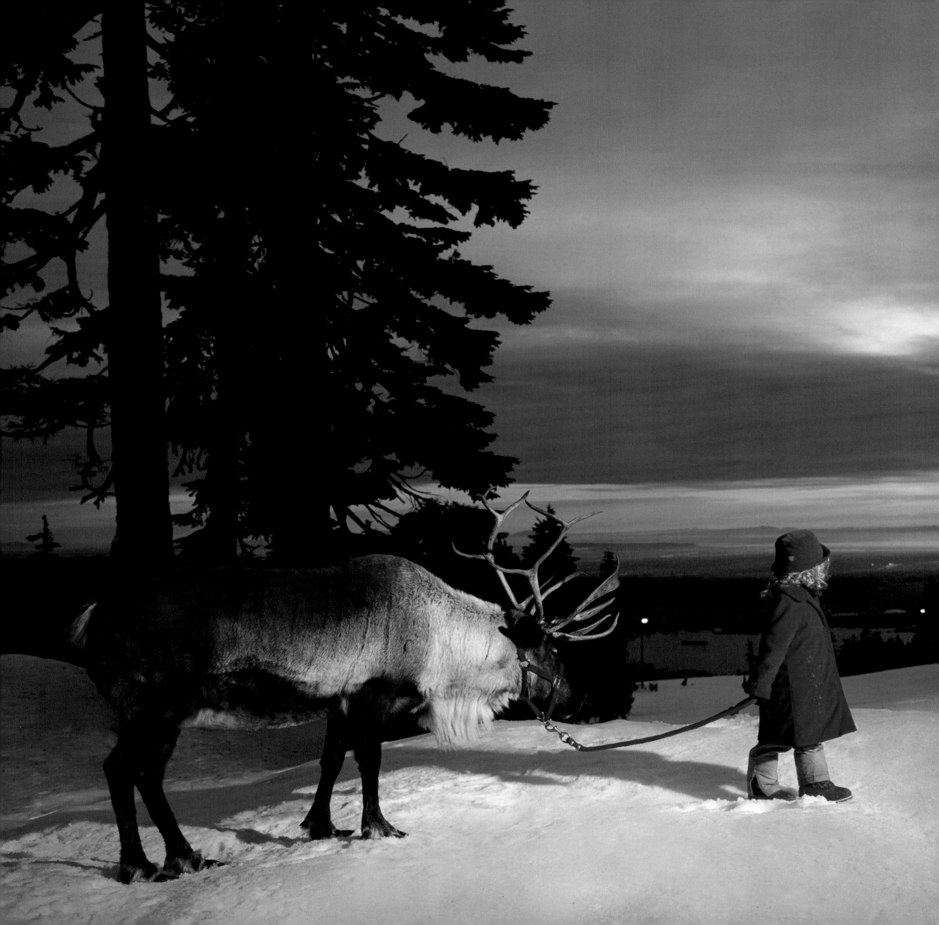

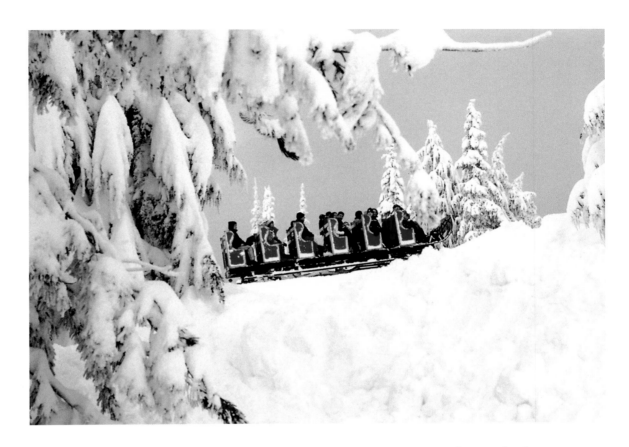

Mountaintop sleigh rides take visitors on a serene tour through the snow-covered forest.

The annual month-long celebration of Christmas atop Grouse Mountain has won the Canadian Tourism Commission award for Best Christmas in Canada. Holiday carollers, breakfasts with Santa Claus, and classic holiday cartoons presented in the Theatre in the Sky are some highlights of the Peak of Christmas celebration.

A stone's throw from the warmth of the chalet, the 8,000-square-foot outdoor skate pond is a nostalgic reminder of Canadian winters past. Nestled next to a wood-burning hearth, the pond is typically frozen over as early as October. Its surface benefits from meticulous grooming courtesy of a mountaintop Zamboni.

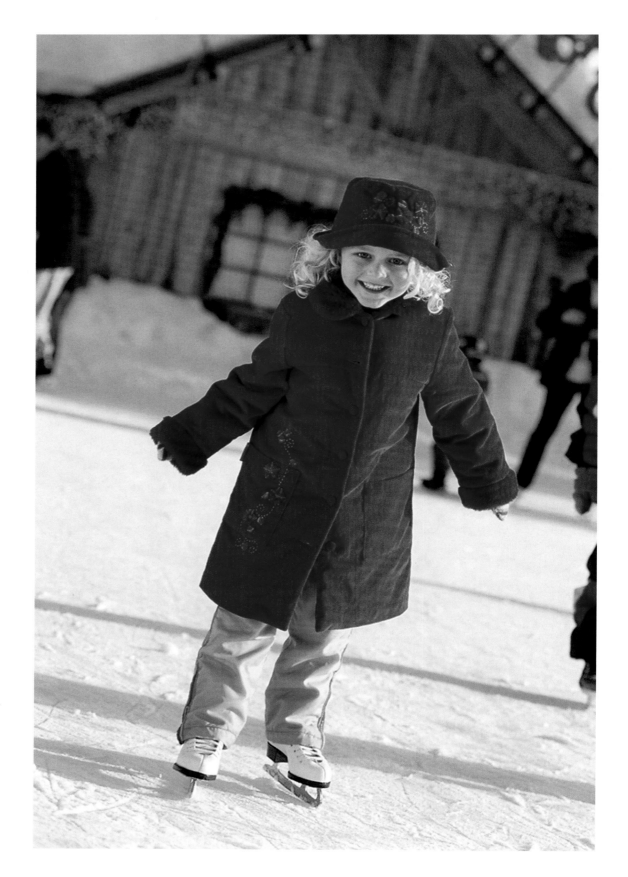

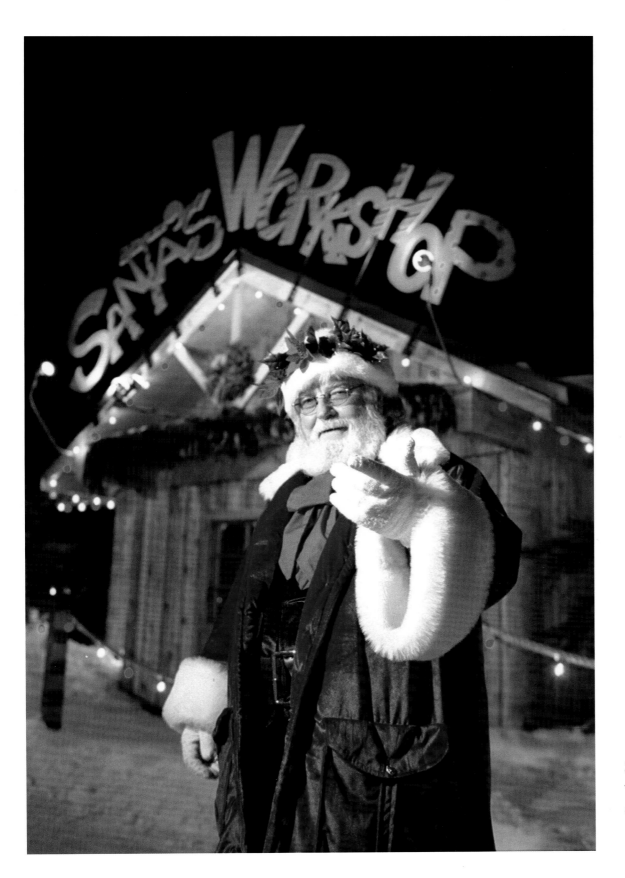

Santa Claus and his reindeer visit Grouse Mountain's Peak of Christmas.

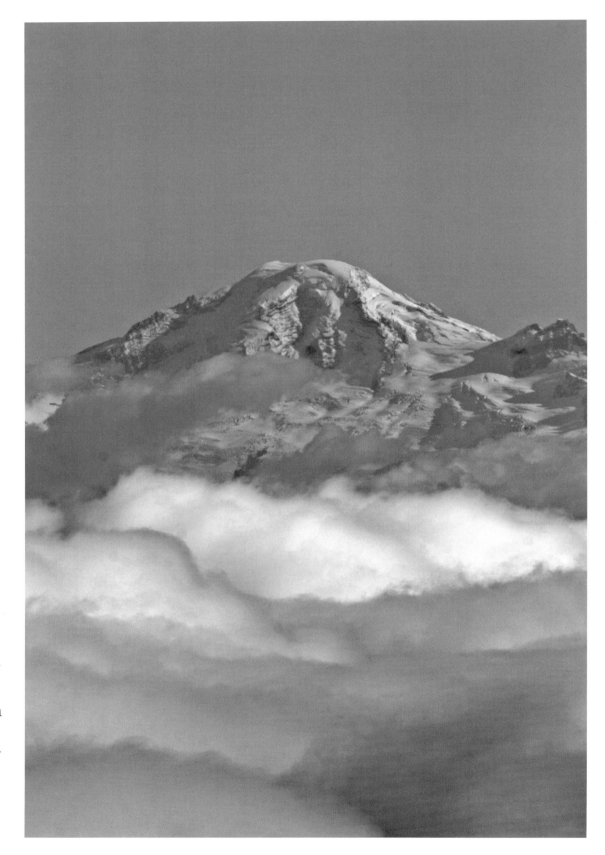

This view of the perennially snow-capped peak of Mount Baker in Washington State, USA, offers a bold contrast to a sunny summer day on the North Shore of Vancouver.

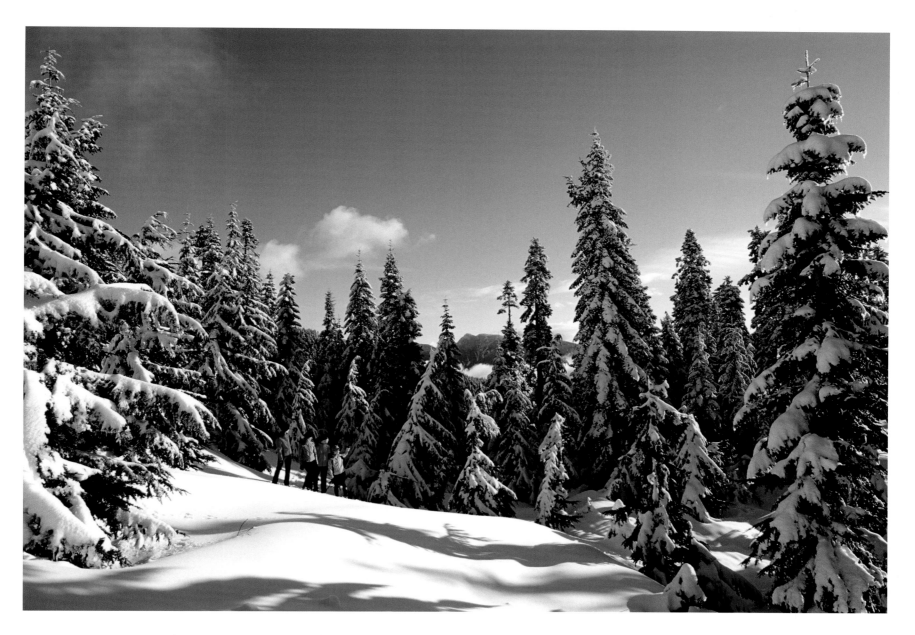

Snowshoeing is Canada's fastest growing winter sport, attracting both elite athletes and casual hikers. Grouse Mountain's facility and the affordability of the sport contribute to snowshoeing's appeal across all age groups.

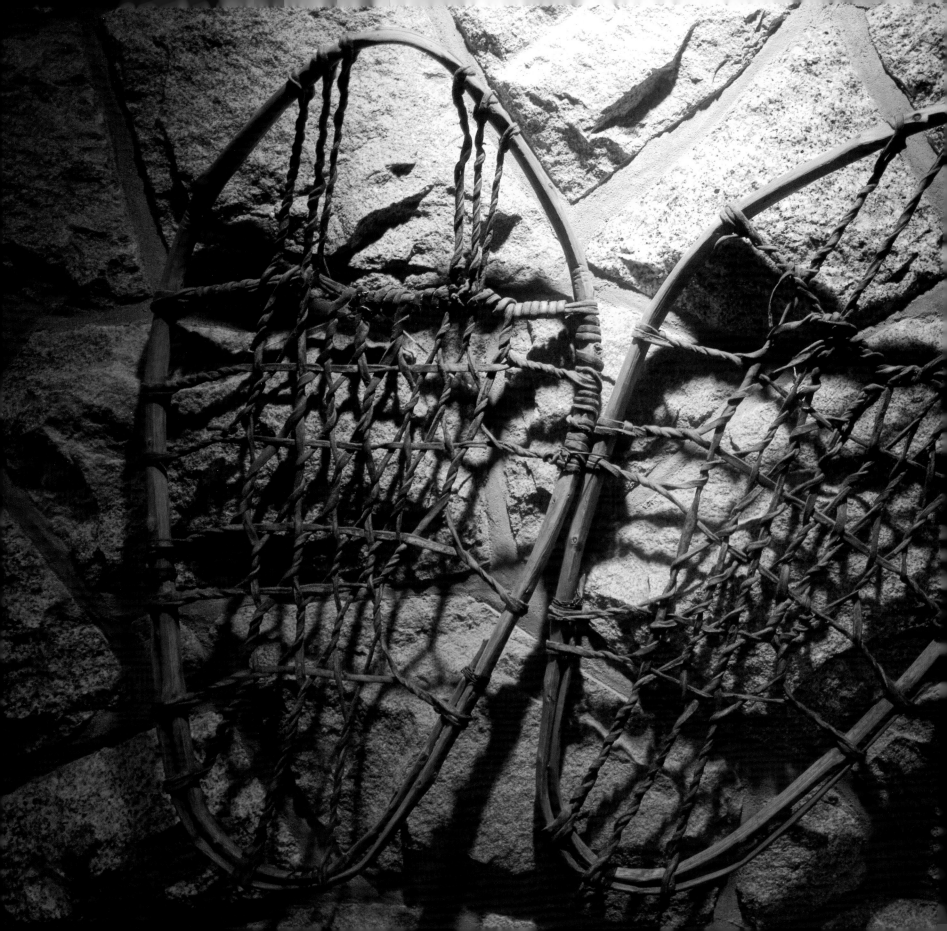

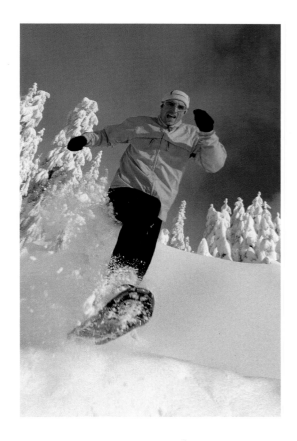

Grouse Mountain is the gateway to richly varied snowshoe terrain. Snow-capped trees and seemingly endless panoramic views abound as hikers make their way to the summit of neighbouring Dam Mountain.

Modern-day snowshoes are a far cry from the tennis-racket style of the last millennium *(left)*. Today, they are sleek, lightweight, and durable. The front end of a modern snowshoe is equipped with a crampon, making it possible to traverse steep terrain without slipping.

25

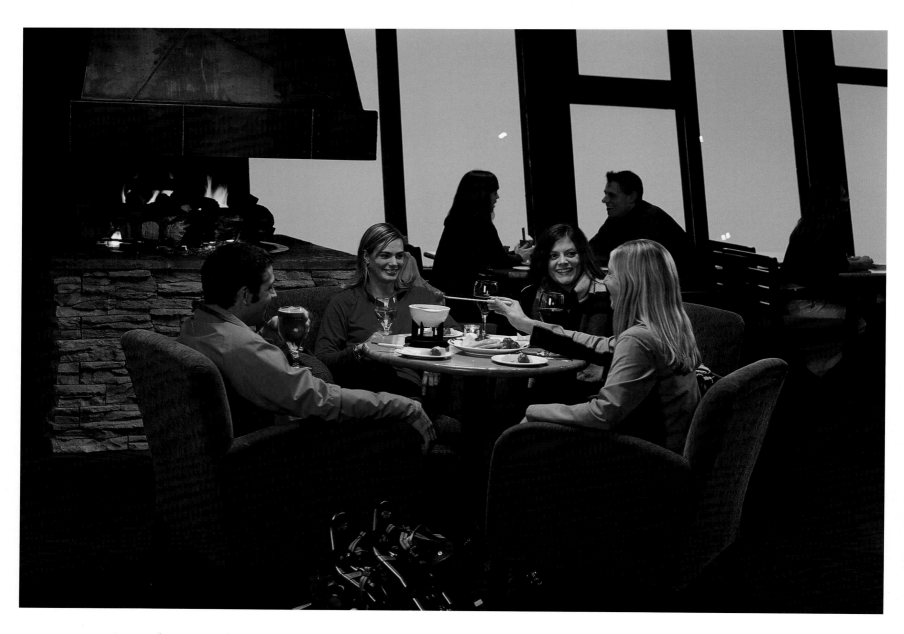

Snowshoe Fondue Tours combine the best of two worlds. Experience the exhilarating alpine air one minute and the decadence of a three-course fondue beside a roaring fire the next.

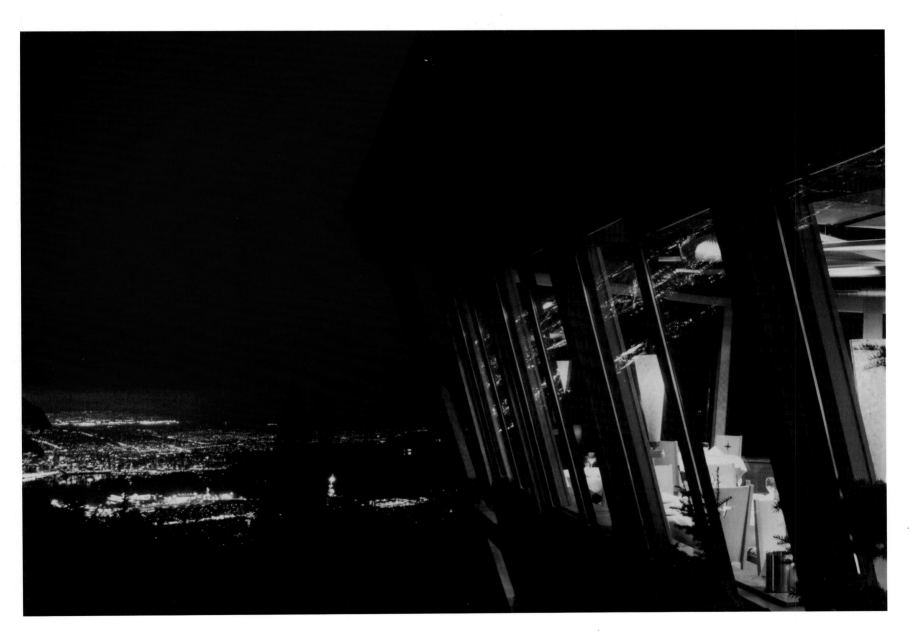

Spectacularly situated on the top floor of Grouse Mountain's Peak Chalet, The Observatory is the crown jewel of the resort's restaurant collection. The Observatory's culinary team uses local and organic ingredients to craft dishes that showcase the best of BC, while leaving a minimal environmental footprint.

Grouse Mountain's Peak Chalet is perched near the southernmost precipice of the mountain, providing unlimited views of the Lower Mainland. It is home to a wide array of dining venues, retail shops, banquet facilities, and information centres.

First-time visitors to Grouse Mountain are often pleasantly surprised by the rustic elegance of the Chalet's interior. The expansive three-story structure of cedar and glass is home to sophisticated design pieces by some of the province's top artisans.

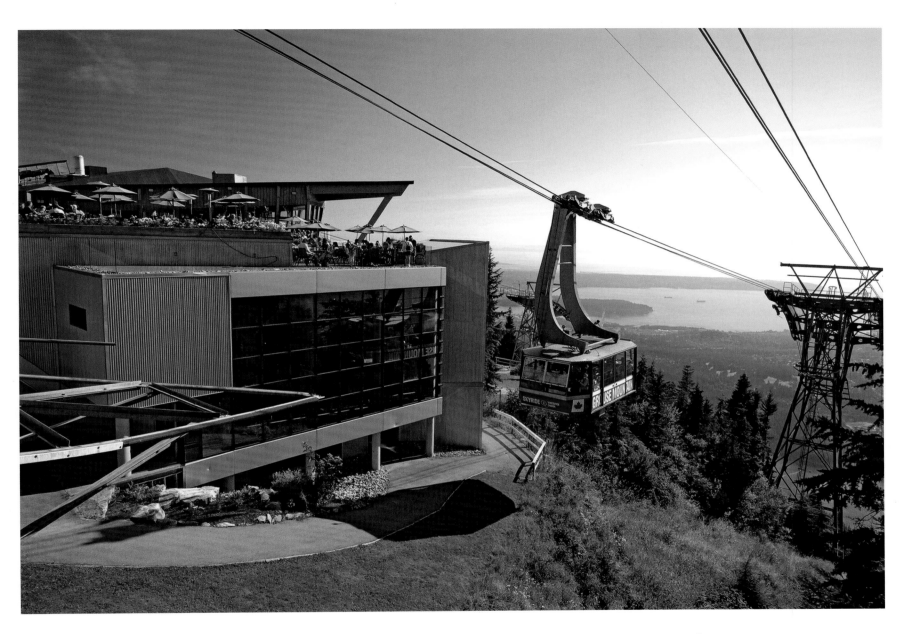

Noted for its resolutely West Coast menu, featuring contemporary tapas and innovative cocktails, Altitudes Bistro boasts what is arguably the province's most spectacular outdoor patio. Situated on the top floor of the Peak Chalet, the west-facing bistro has hosted several unforgettable events. The splendour of the venue's surroundings has caught the attention of many high-profile event planners.

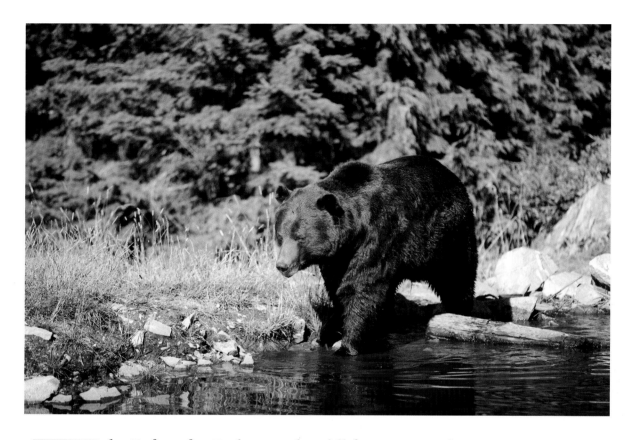

The Refuge for Endangered Wildlife is a research, conservation, and education centre. It provides a second chance for at-risk indigenous species and aims to be a world leader in this undertaking.

Resident grizzly bears Grinder and Coola came to the Grouse Mountain Refuge in 2001 as cubs and have served as ambassadors for their species ever since. The two grizzlies, though not brothers, have become the best of friends since living together in their five-acre mountaintop habitat. They can often be seen splashing about in one of their ponds or playfully wrestling in the woods. Grinder and Coola have brought an awareness of the grizzly bear's plight to millions of visitors.

The data collected by Grouse Mountain's team of wildlife professionals and volunteers will help establish a rehabilitation protocol for future orphaned grizzly cubs.

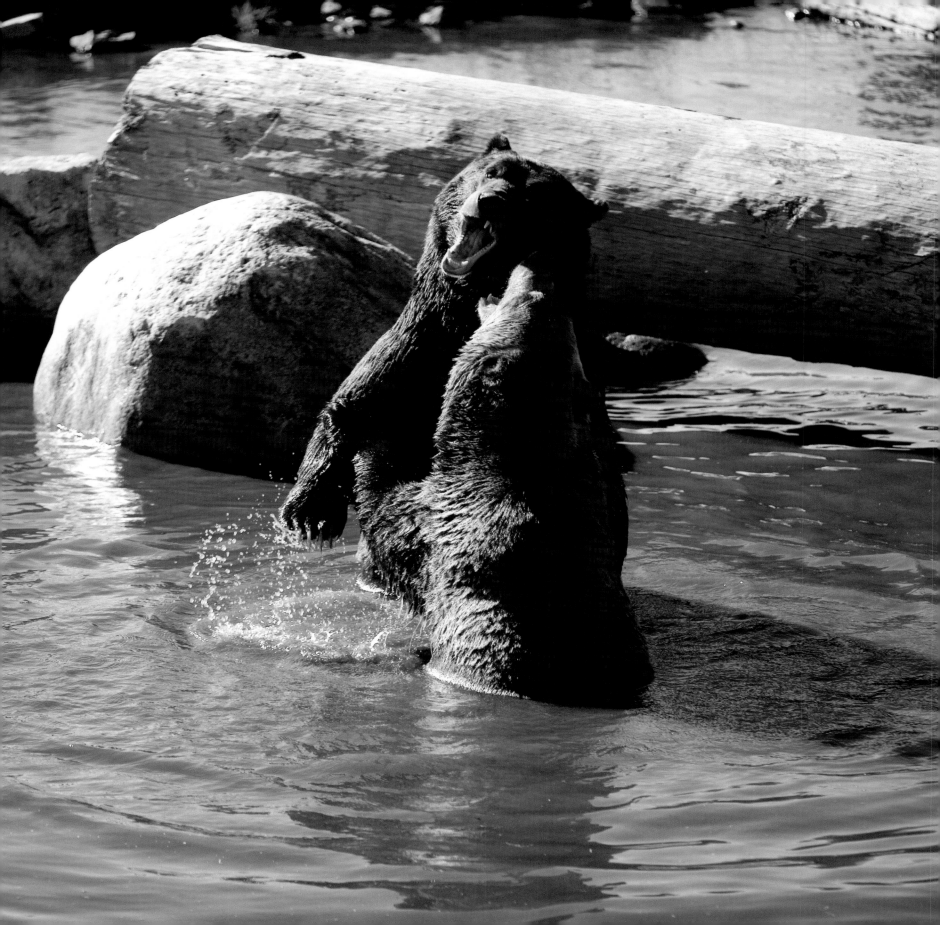

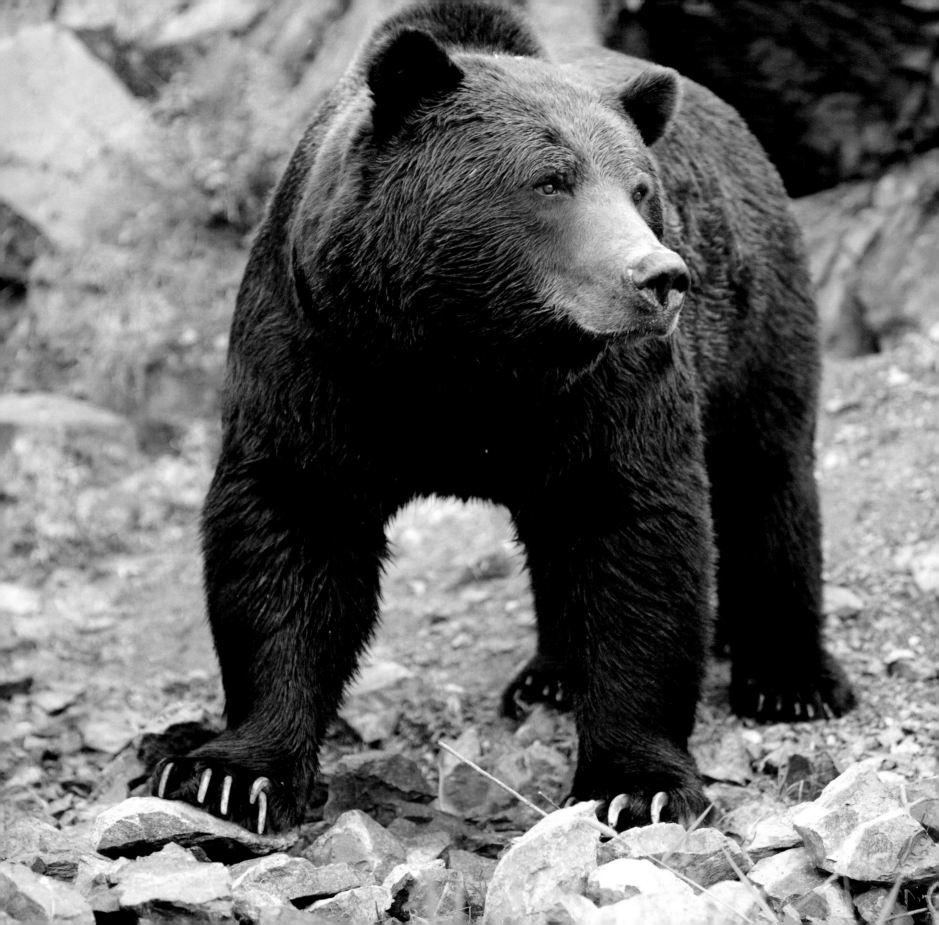

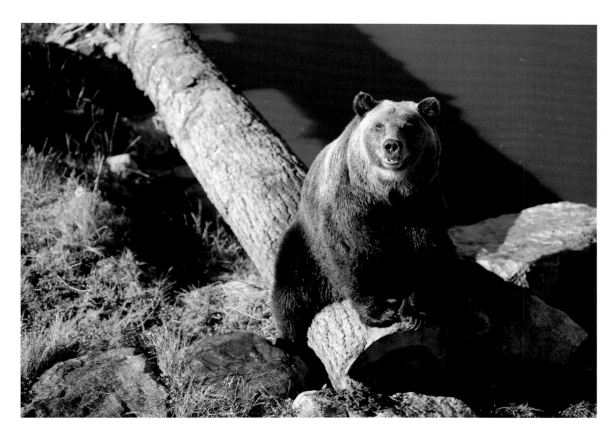

The five-acre Grizzly Bear Habitat is a natural expanse of mountaintop forest that includes ponds, rocky crags, steep hills, and deep woods.

A grizzly bear (also known as a brown bear) and a black bear can be distinguished by their physical features. Grizzlies have a distinct hump of heavy muscle on their backs above their shoulders and tend to have less angular faces than black bears.

Grizzly bear Coola (*left*), originating from BC's coastal region, is larger than Grinder (*above*), who hails from BC's interior. Coastal grizzly bears have access to protein-rich diets that include salmon and other fish, whereas grizzly bears from the interior do not enjoy the same abundance. Grinder is named after the famous Grouse Grind hiking trail that makes its way up the southern slope of the resort. Coola is named after Bella Coola, the region where he was found orphaned.

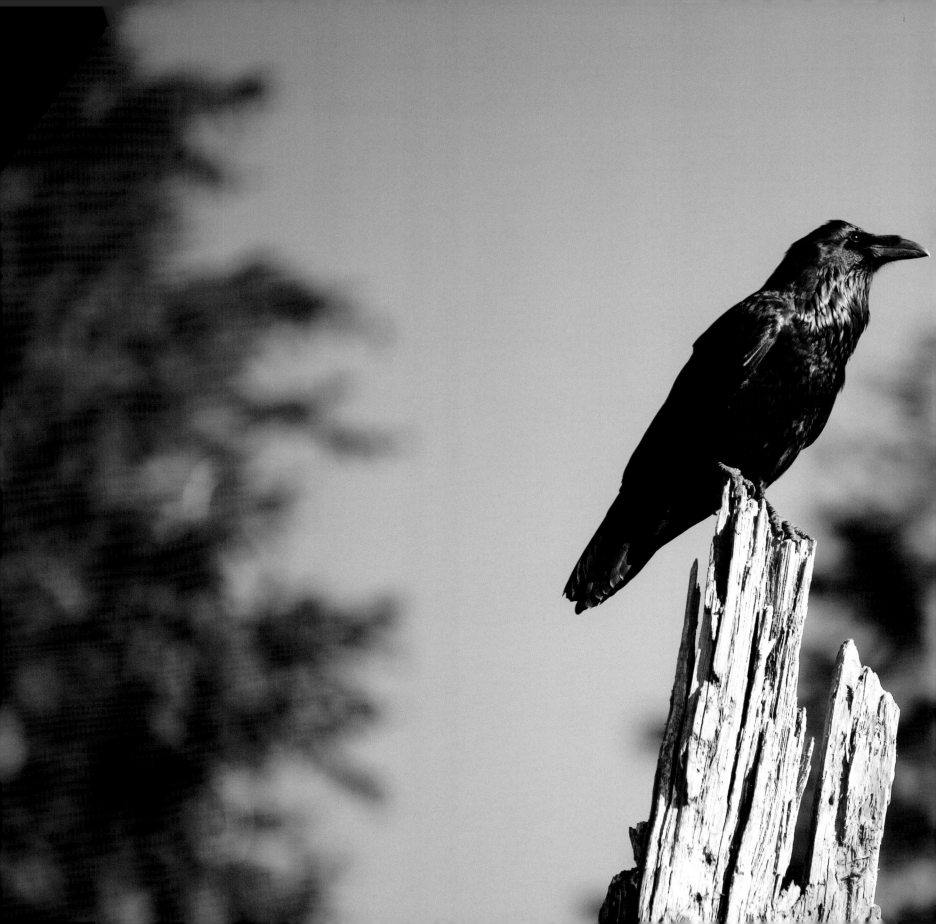

Sizable ravens are ubiquitous on the mountaintop, where they find ample nourishment in the dense forests.

When Grouse Mountain wildlife is abundant, Wildlife Rangers host daily interpretive talks.

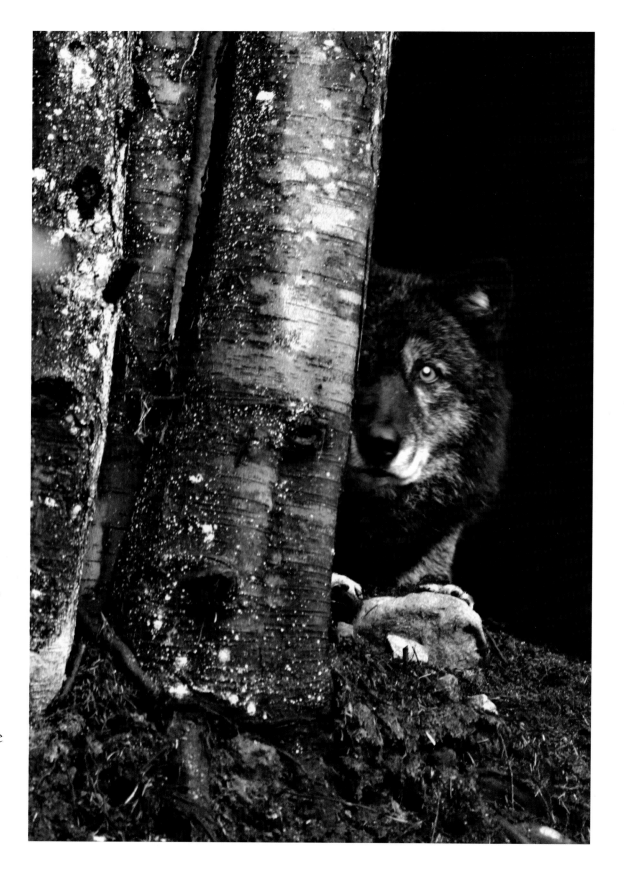

The wolves of Grouse Mountain's Refuge for Endangered Wildlife are retired from the film industry. Born and raised in captivity on a BC farm, these wolves now enjoy the largest and most natural home they've known—the Wolf Habitat.

The Wolf Habitat is located in Grouse Mountain's valley, just north of the treeline.

With their pack mentality, the wolves were eventually deemed unsuited to film industry work. Grouse Mountain was happy to give them a second chance at life in an expansive natural habitat.

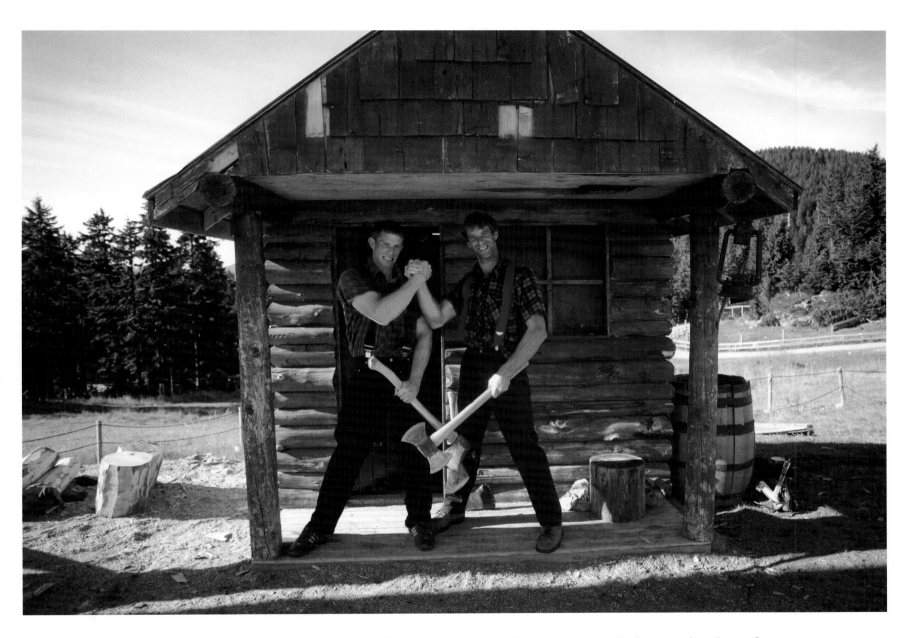

Competing lumberjack camps vie for top spot in a humorous and daring display of athleticism in the World Famous Lumberjack Show. Lumberjack Show competitors adopt the traditional character names of Willie McGhee and Johnny Nelson. They hail from the Blue Mountain and Green River logging camps, respectively.

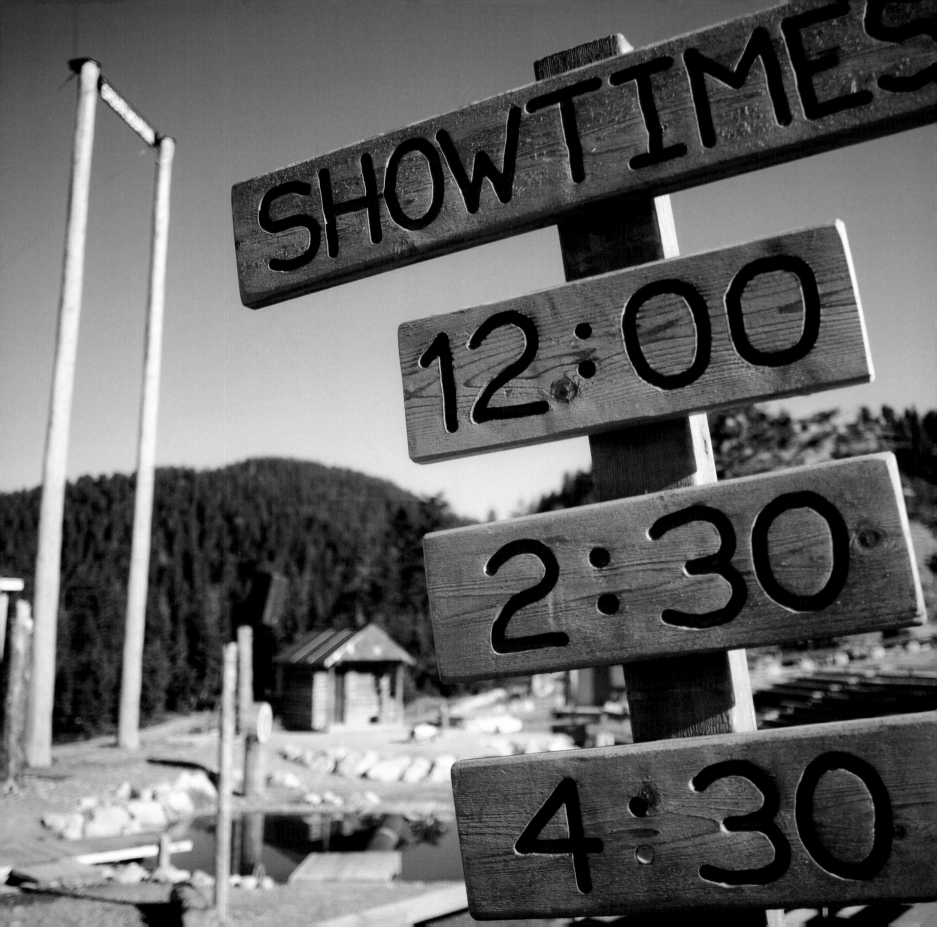

It takes a keen eye and a steady hand to land a bull's eye in the axe-throwing competition.

The Grouse Mountain World Famous Lumberjack Show takes place three times a day throughout the summer months. *(left)*

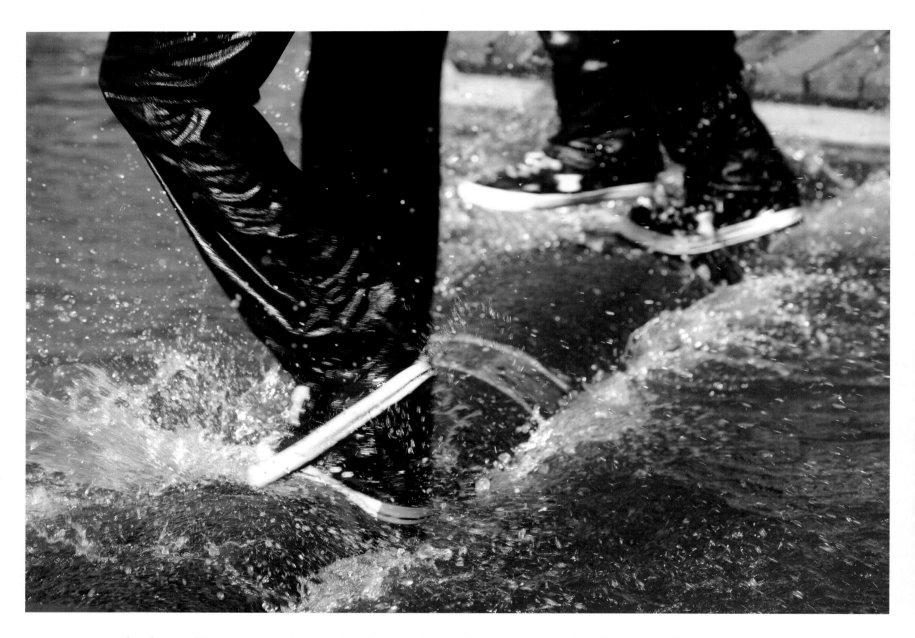

The log rolling competition pits the lumberjacks against each other on a free-spinning log that floats on the surface of a pond. Athletes struggle to throw their opponent from the log with fancy footwork and considerable splashing.

The speed climbing competition is a crowd favourite. Fitness levels are put to the test as lumberjacks race to the top of a 60-foot tree. The descent is a sight to behold as the loggers virtually free-fall to their starting position in order to clock the best time. *(right)*

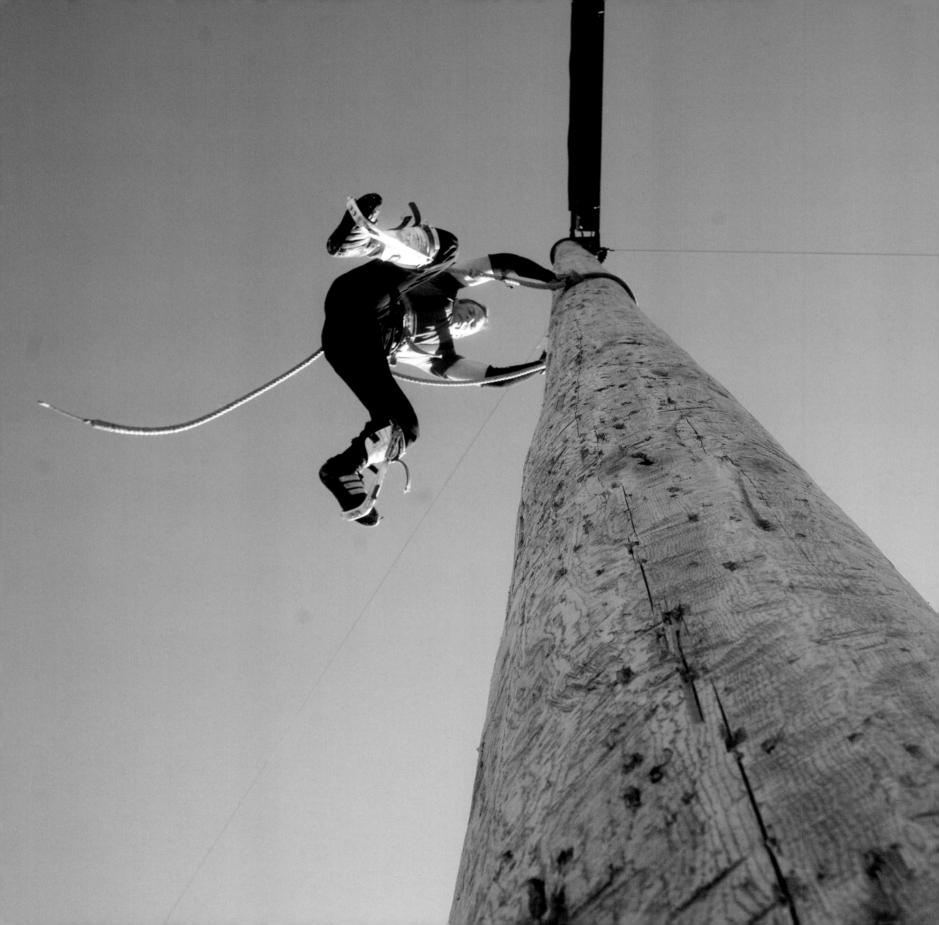

A lumberjack is set off balance and falls into a well during a humorous portion of the World Famous Lumberjack Show.

42

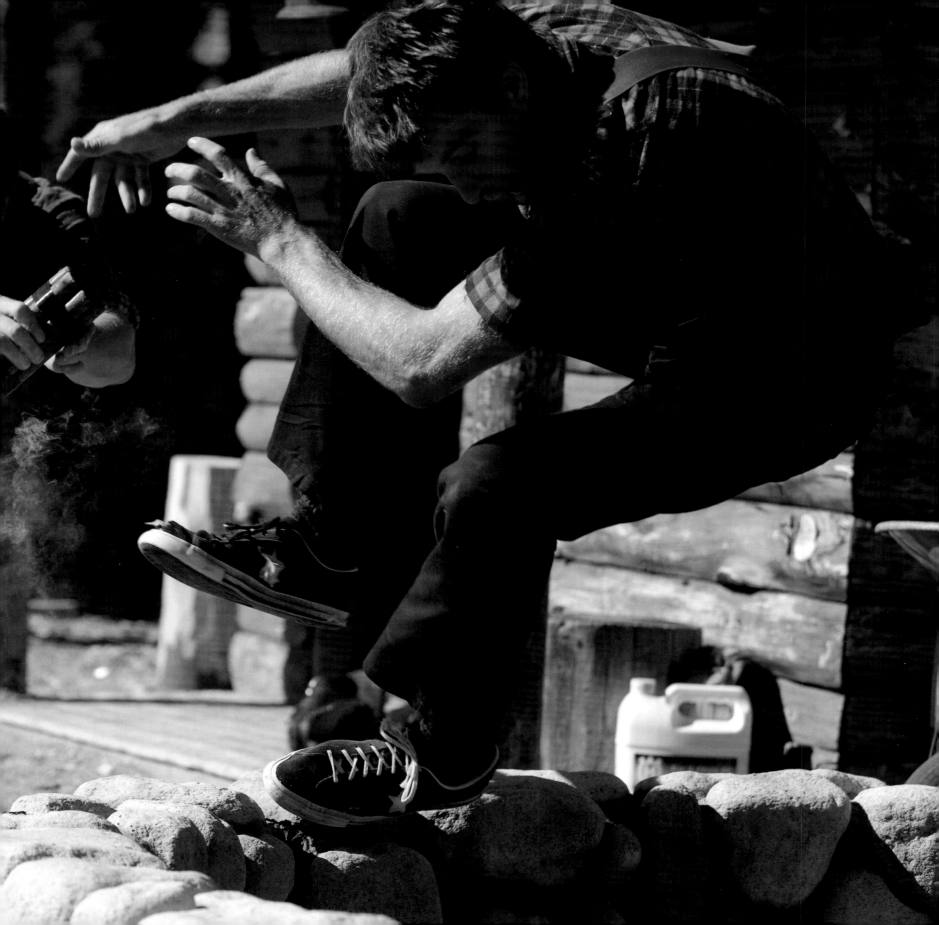

The Lions, which are the two
highest peaks in the Capilano
River Valley, stand at 5,200
and 5,400 feet above sea level.
Forestry along the banks of
the Capilano River has been
an important part of British
Columbia's economy and has
included work sites in the lower
elevations of Grouse Mountain.

The distant mountains of
Vancouver Island seem like
they're just down the road
when viewed from atop Grouse
Mountain on a clear day. *(right)*

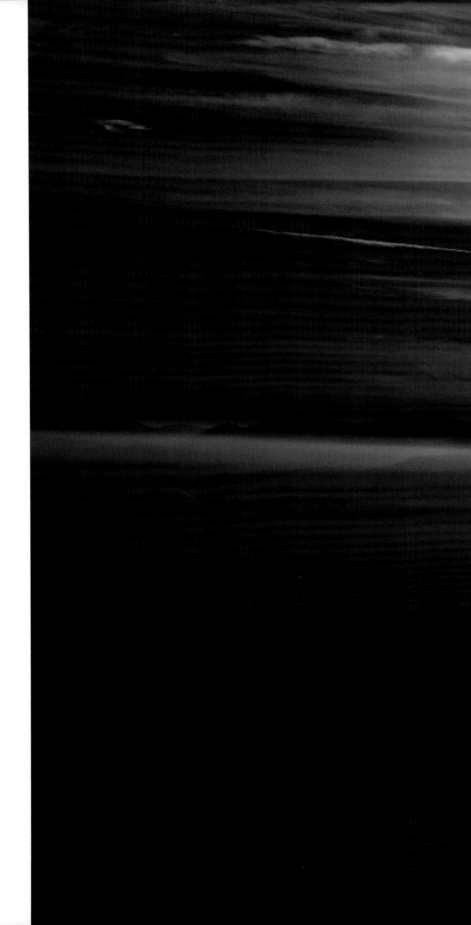

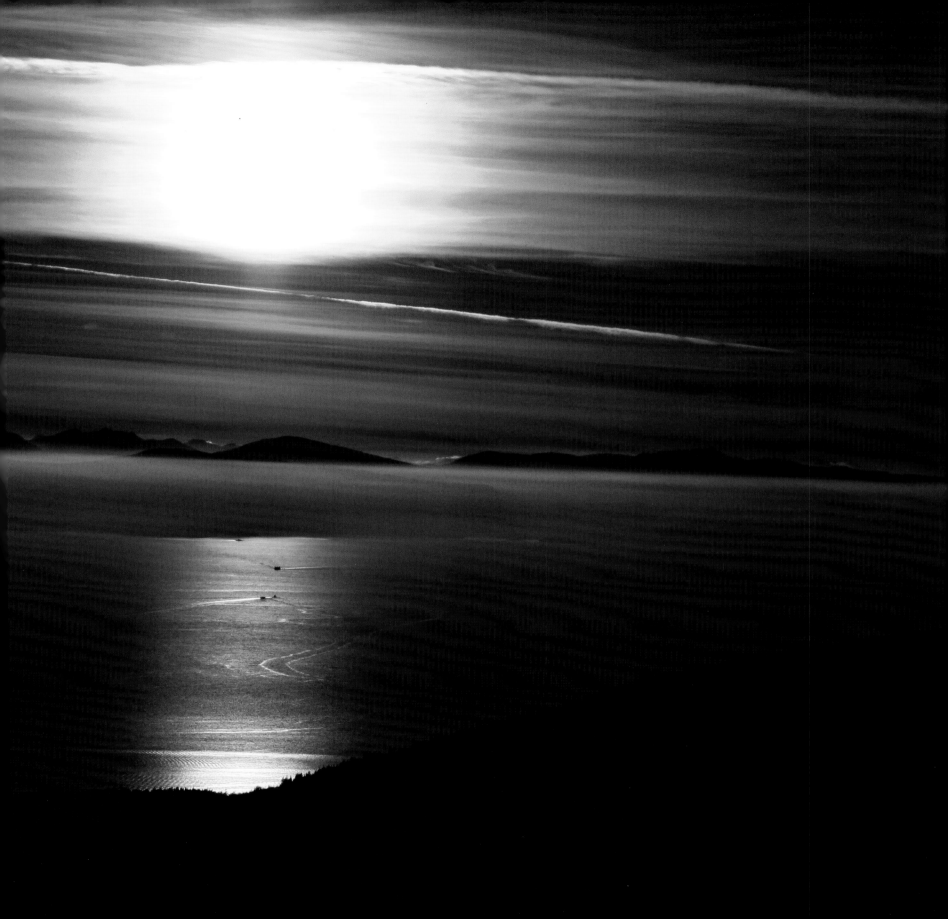

It is a true Vancouver bragging right to have a "Grouse Grind time." The gruelling 2.9 km hike up the south face of the mountain draws over 100,000 ambitious hikers every season.

Official Grouse Grind record ascent times are set during the annual Grouse Grind Mountain run that takes place in the fall.

Record ascent times hover in the staggering 26-minute range! To put that into perspective, the average person in good cardiovascular condition should expect to take one hour to hike the Grind.

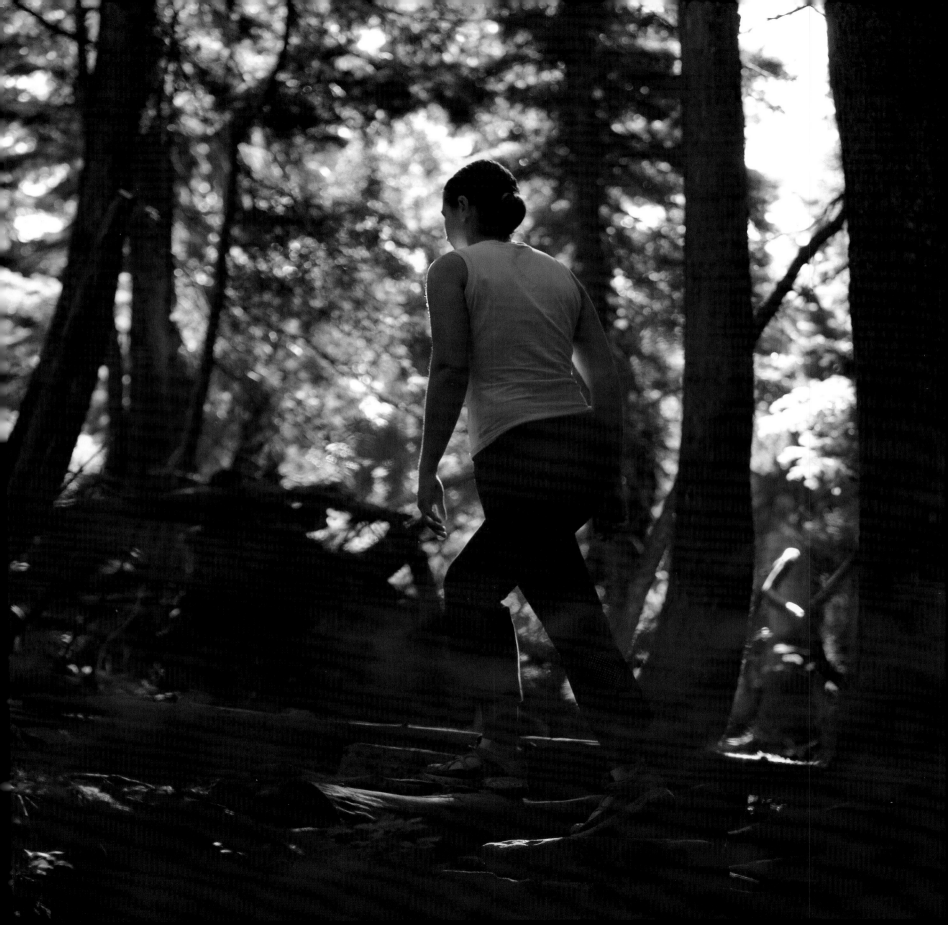

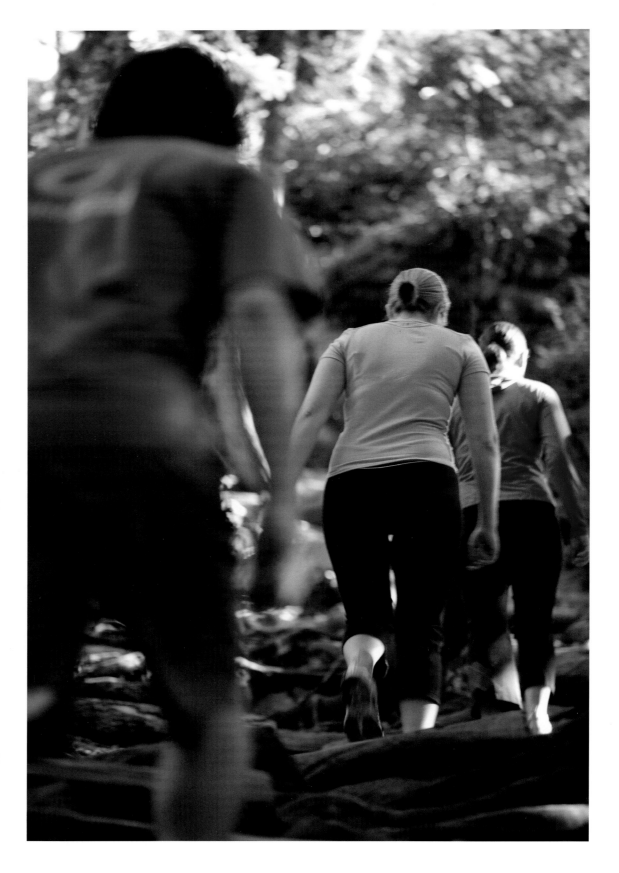

Also known as Mother Nature's Stairmaster due to its unique topography, the Grouse Grind is an intense cardiovascular workout that is roughly equivalent to a 10-km run.

Summit Seeker cards are unique timing devices used by Grinders to keep track of their hiking progress. Statistics maintained by the Summit Seeker program include an "equivalent distance" feature. For instance, 24 Grind hikes are equivalent to the elevation of Mount Kilimanjaro.

Local First Nations artist Glen Greensides was commissioned to develop an awe-inspiring set of wooden sculptures for the meandering mountaintop pathways and trails. His cedar carvings, collectively called *Tribute to the Forest*, reveal the importance of old-growth forests to our province. Each carving, made of naturally felled timber, stands approximately 16 feet tall. Amazingly, over 95 percent of the intricate detailing of these sculptures was completed using a chainsaw!

The lush meadows of Grouse Mountain are part of the rich and thriving ecosystem we know as the Pacific Coastal Rainforest. This vast network of co-operative, interactive species is a true national treasure.

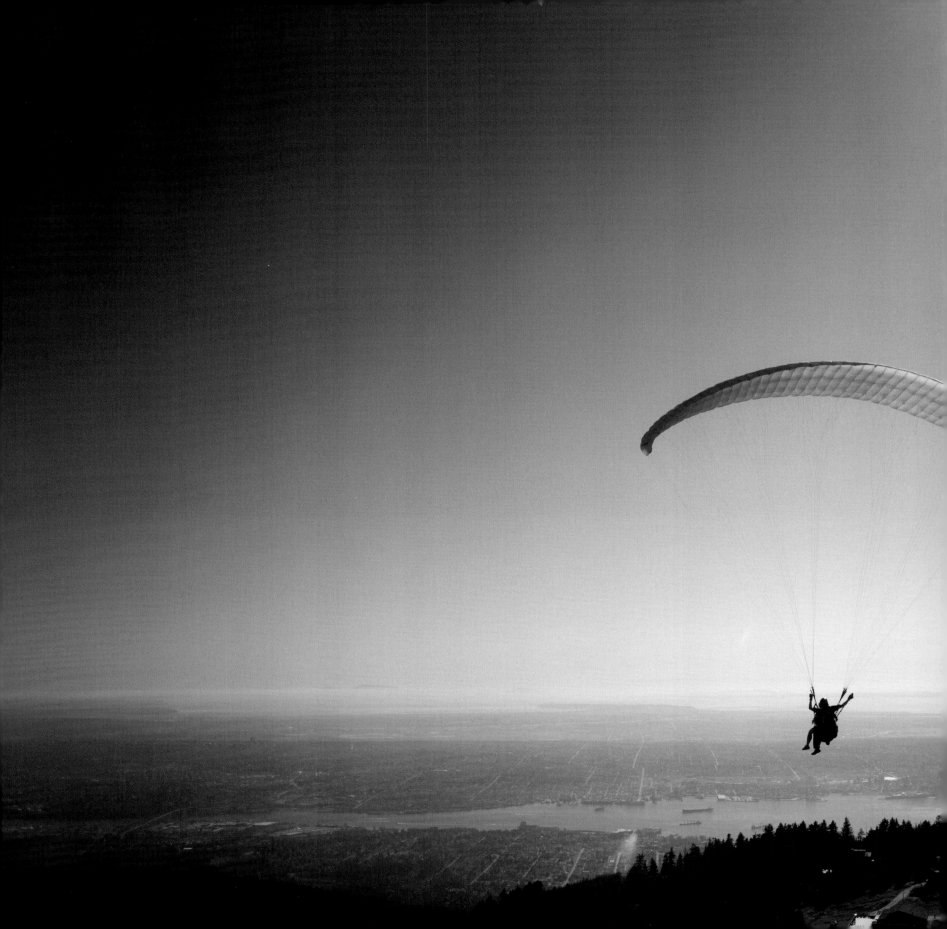

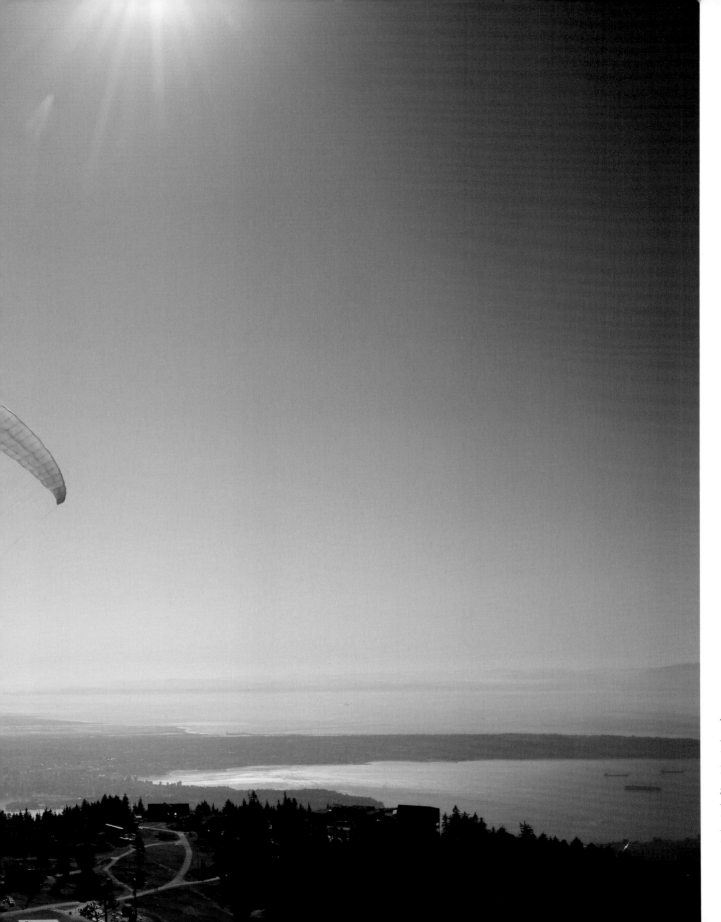

The peak of Grouse Mountain rises 4,100 feet above sea level and makes an ideal launch pad for tandem paragliding flights.

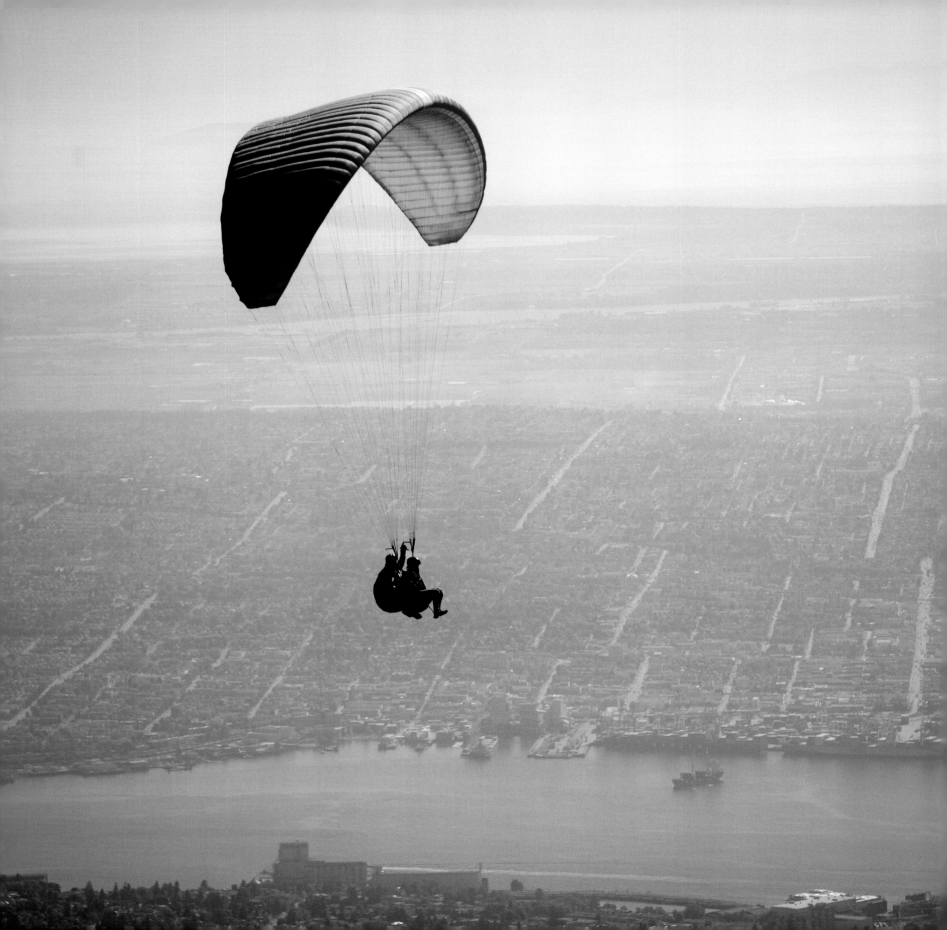

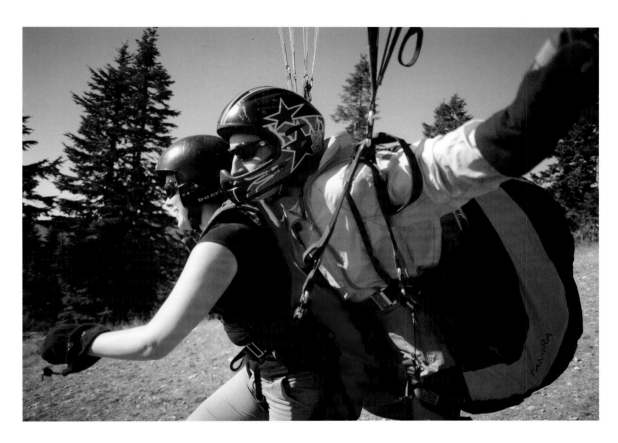

Champion paragliders instruct participants in proper launching techniques before their first flight.

Soaring with the eagles high above the vibrant valley during a tandem flight. *(left)*

Grouse Mountain is proud to be the North Shore's largest youth employer. While the enviable perks include unlimited skiing and riding throughout the winter, the exceptional learning opportunities and strong sense of belonging at this family-owned company are what keep employees on board year round.

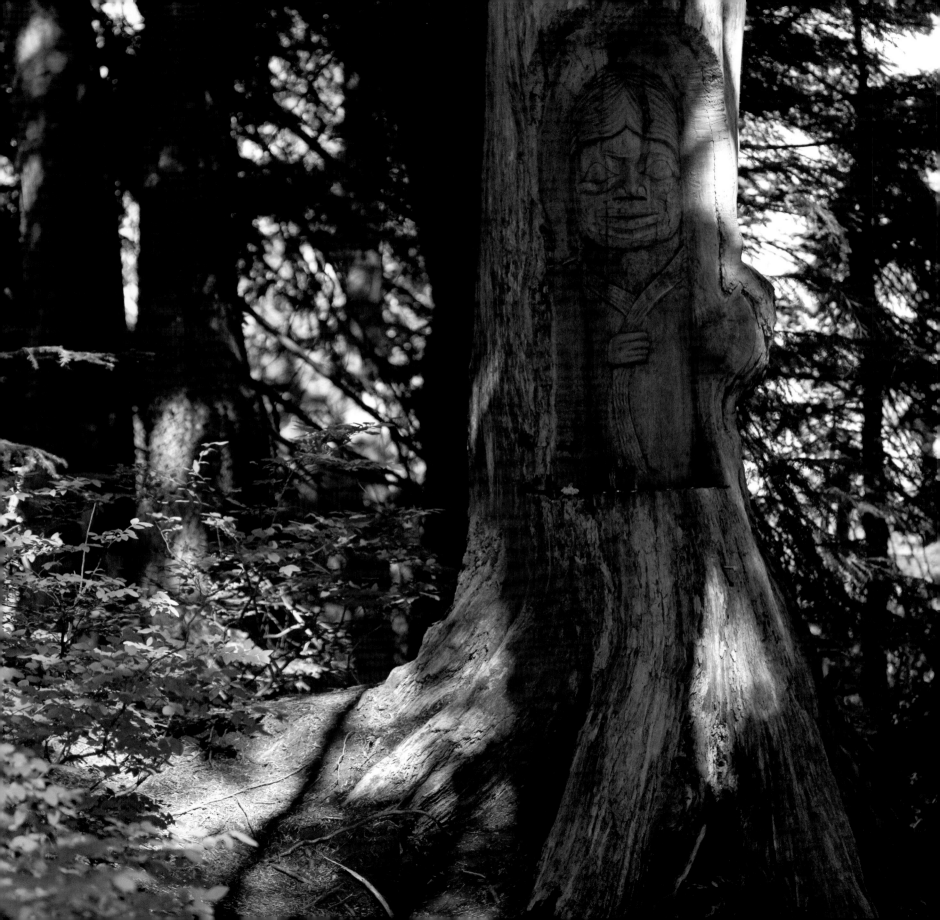

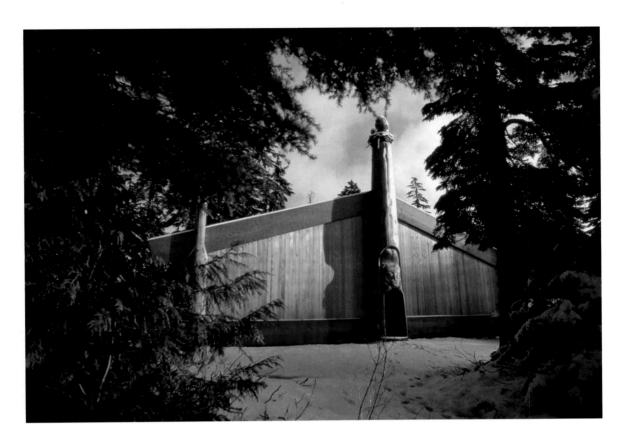

Constructed in 1997 under the guidance of prominent Coast Salish community elders, the *hiwus* Feasthouse is an authentic First Nations cedar longhouse traditionally used for welcoming family and friends. It is situated deep in the alpine forest along the shores of Blue Grouse Lake. The rich aroma of cedar boughs and wafts of smoke from the central fire pit contribute to the sensory experience at the *hiwus* Feasthouse.

The symbolism of the Spirit Tree is well expressed by Coast Salish artist Richard Krentz, who says, "On the outside we may look old but inside there remains a beautiful spirit. As First Nations people we spoke to the high spirit in each other, and our grandmothers helped remind us of those values. This teaching helped us to live together in harmony and peace." *(left)*

59

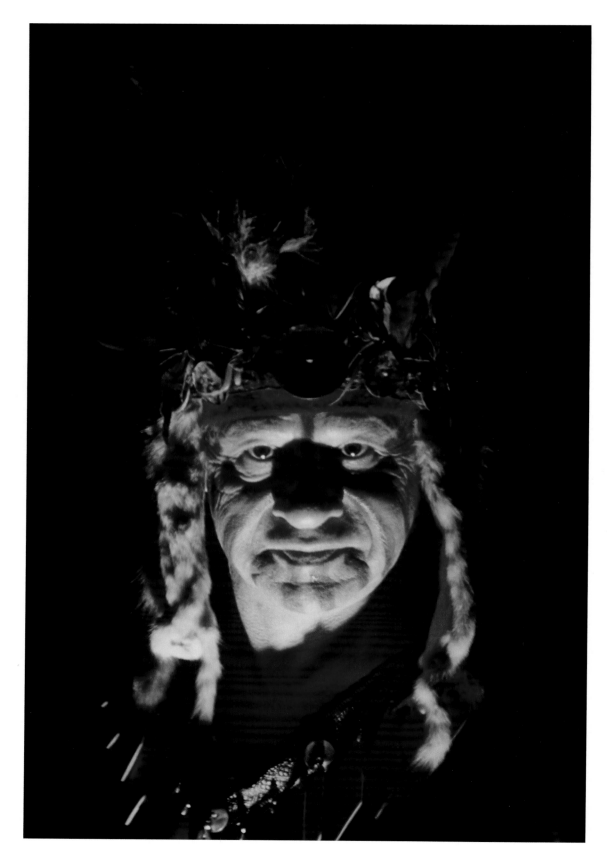

Members of the Coast Salish Nations share their culture within the walls of the cedar longhouse.

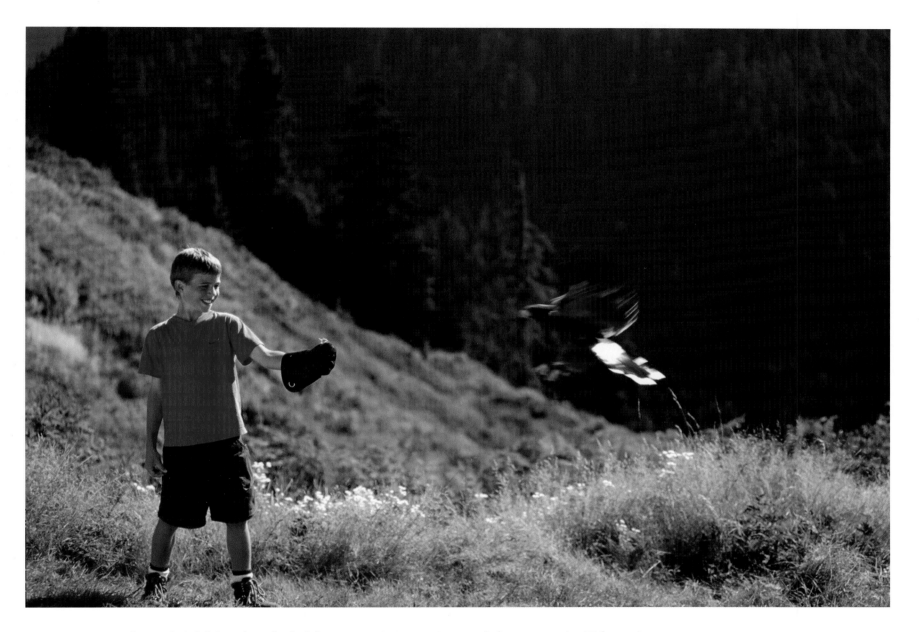

Over 15,000 school children participate in an Adventure in Education program every year. The programs are created to complement the curriculum goals of Lower Mainland schools and focus on such areas as endangered species, First Nations culture, snow sports, and the physics of winter.

Grouse Mountain's alpine plaza is the departure point for spectacular hiking terrain. A network of marked trails takes hikers through the Lynn Headwaters region to the neighbouring peaks of Dam Mountain, Goat Mountain, and Thunderbird Ridge.

The shores of Blue Grouse Lake (*right*) border the rolling pathways of the Eco Walk. Aside from its obvious aesthetic appeal, the lake is also a functional reservoir—drawing from an alpine source—that provides water for Grouse Mountain's snowmaking fleet.

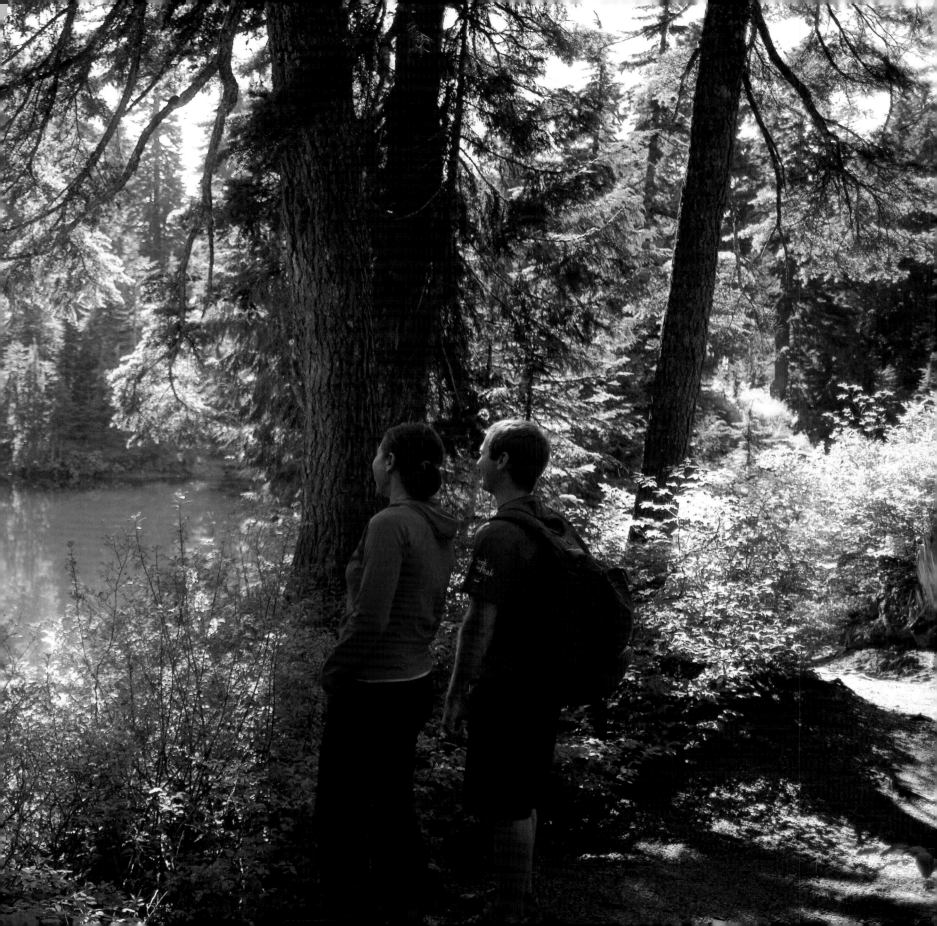

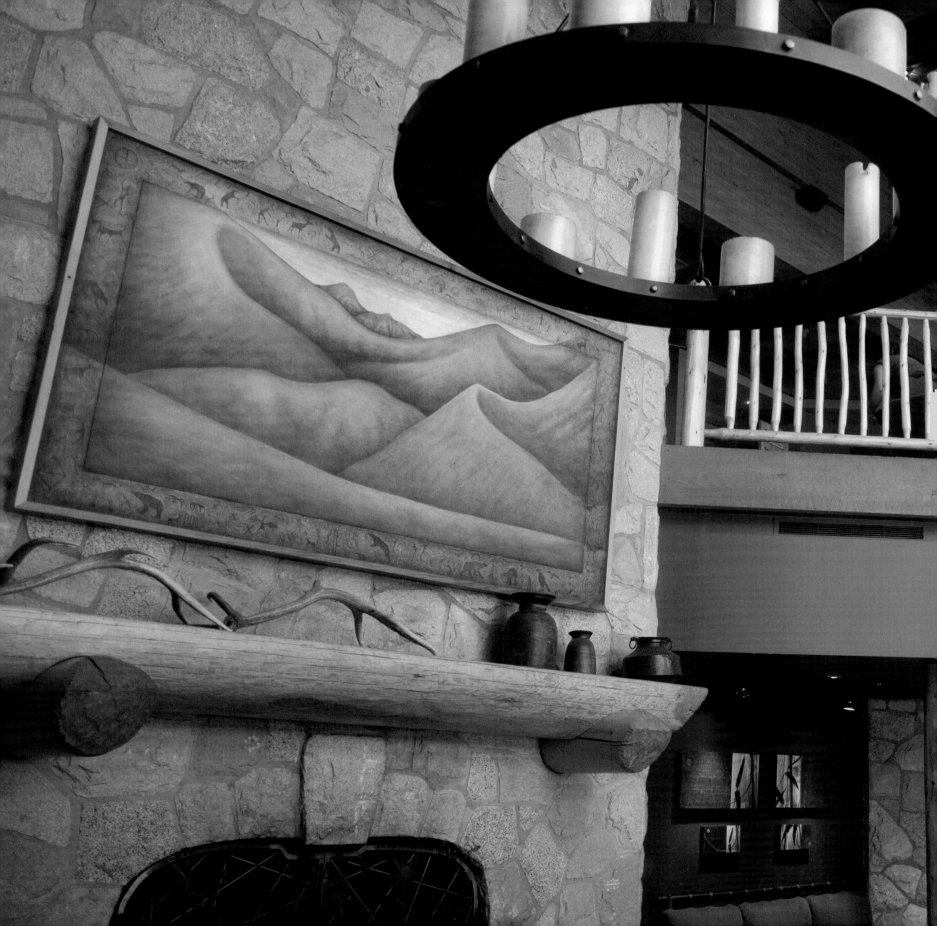

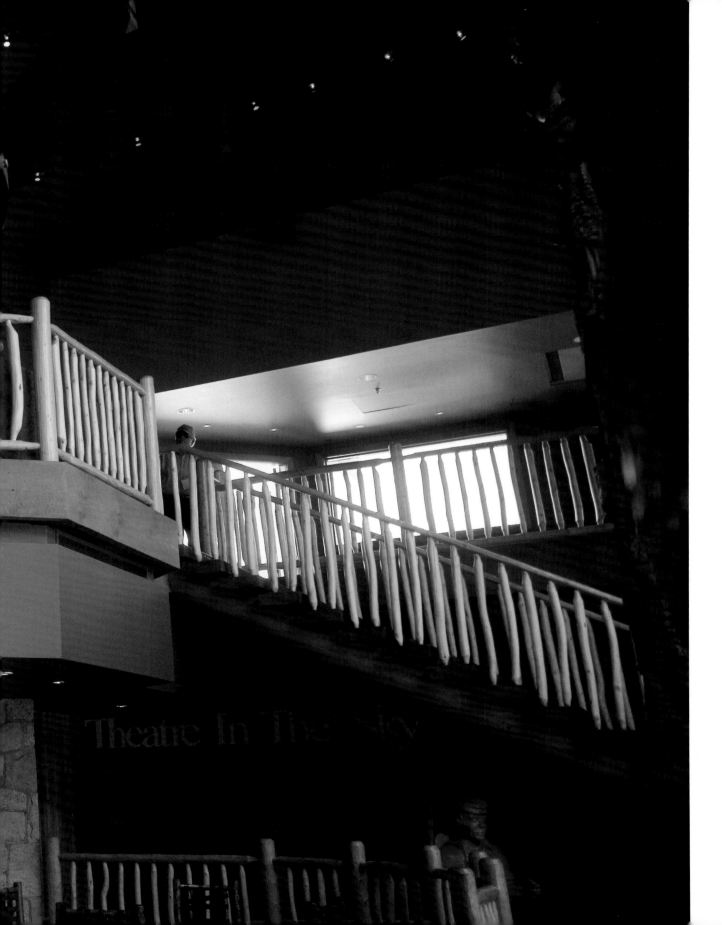

The Theatre in the Sky is Canada's first high definition cinema. The feature film, *Born to Fly*, takes the audience on a scenic overview of southwestern British Columbia from an eagle's perspective.

For as many as 10,000 years, discoverers, adventurers, and travellers have been drawn to Grouse Mountain, one of the Pacific Northwest's best-known landmarks.

The First Peoples believed that the world consisted of all that they could see from the mountaintop. Oral traditions and archeological findings suggest that Polynesian and Japanese voyagers may have sailed the nearby waters as early as the 14th and 15th centuries. During the 17th and 18th centuries, Russian, Spanish, and British explorers, trappers, and traders visited the straits, sounds, narrows, and bays at the base of the mountain. By the second half of the 19th century, settlers and loggers stood on the top of Grouse, attracted by the breathtaking vistas of indigo-blue water, jade-green forests, islands, and misty mountains that extend as far as the eye can see. By the early 20th century, pioneer residents of Vancouver were spending their summers in cottages and cabins on the North Shore and from that time forward, generations of hikers, picnickers, and eventually skiers succumbed to the beauty of Grouse.

As we begin the 21st century, Grouse Mountain remains the pinnacle, the peak, the lookout, and one of the world's great natural observatories.

Welcome to The Observatory, Grouse Mountain's finest restaurant—taking standards of food, beverage, and hospitality to new heights.

# Recipes

# Poached Bosc Pear and Aged Cheddar Salad

*winter greens, buttermilk cream, maple candied pecans, pear and walnut vinaigrette*

*Serves 6 – 8*

## Poached Pears

*5 Bosc pears*
*1½ cups (375 mL) apple cider vinegar*
*2 cups (500 mL) water*
*1 cup (250 mL) white sugar*
*½ cup (125 mL) finely grated fresh ginger*
*1 red chili pepper*
*1 cinnamon stick*
*6 whole juniper berries*
*1 tsp (5 mL) black peppercorns*
*3 whole cloves*
*1 bay leaf*

Combine all the ingredients in a large stock pot. Place an oven-proof plate over top of the pears, to keep them down. Place the pot over medium heat and bring the contents to a simmer. Turn the heat off and allow to sit for 30 minutes, or until the pears are tender. Once tender, take them off the heat and allow to cool completely. Cut away all four sides of the pear, leaving the core to be discarded. Slice the sides into segments.

## Maple Candied Pecans

*1 cup (250 mL) pecan halves*
*½ cup (125 mL) maple syrup*
*Australian flake salt to taste*

Preheat the oven to 350°F (180°C).

Toss the pecans with the maple syrup and season lightly with the salt. Lay them on a baking tray lined with parchment paper and bake in the preheated oven for approximately 12 minutes, or until the syrup begins to caramelize and bubble. Allow to cool, then crumble.

## Pear and Walnut Vinaigrette

*3 Tbsp + 1 tsp (50 mL) pear vinegar*
*1 Tbsp (15 mL) Dijon mustard*
*6 Tbsp (100 mL) liquid from Poached Pears*
  *(recipe this page)*
*⅛ vanilla pod, scraped and seeded*
*2¼ Tbsp (35 mL) walnut oil*
*⅔ cup (150 mL) grapeseed oil*
*salt and pepper to taste*

Combine pear vinegar and Dijon mustard in a bowl. Add a pinch of salt and pepper and stir to combine. Let rest for one minute while salt dissolves. Add poached pear liquid, vanilla seeds from pod, and stir. Slowly drizzle both oils over the mixture, and whisk until emulsified.

*Recipe continued on next page . . .*

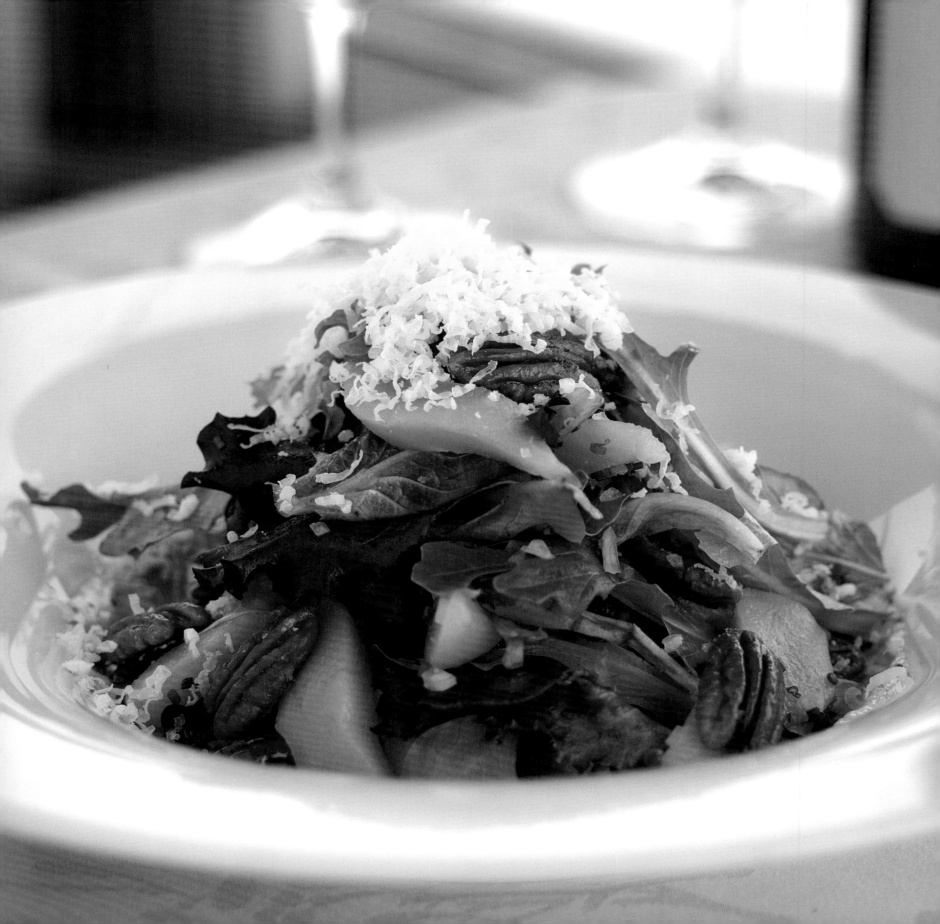

## Buttermilk Cream

*2 egg yolks, from large brown eggs*
*2 Tbsp (30 mL) Dijon mustard*
*4 cloves garlic, minced*
*2 tsp (10 mL) Xeres vinegar*
*juice of 1 freshly squeezed lemon*
*½ cup (125 mL) olive oil*
*2 cups (500 mL) grape seed oil*
*3 Tbsp + 1 tsp (50 mL) buttermilk*
*½ cup (125 mL) 5-year-old cheddar, grated*
*2 Tbsp (30 mL) grainy Dijon mustard*
*¼ cup (60 mL) flat leaf parsley, finely chopped*

Combine the egg yolks, Dijon mustard, garlic, vinegar, and lemon juice in a deep narrow bowl. Using a stick blender slowly add both oils in a thin stream while pulsing the blender. The mixture should emulsify and become the consistency of mayonnaise. Add the remaining ingredients and blend until uniform.

## Salad

*7 cups (2 L) mesclun greens*
  *(mixed organic)*
*⅓ cup (75 mL) shallots, finely chopped*
*⅓ cup (75 mL) chives, finely chopped*
*12 wedges Poached Pears (recipe page 68)*
*½ cup (125 mL) Maple Candied Pecans*
  *(recipe page 68)*
*Pear and Walnut Vinaigrette, as needed*
  *(recipe page 68)*
*3 Tbsp + 1 tsp (50 mL) Buttermilk Cream*
  *(recipe this page)*
*1 cup (250 mL) grated 5-year-old cheddar*
*salt and pepper to taste*

Combine the greens, shallots, chives, pears, and pecans in a medium-sized mixing bowl. Season as desired, then lightly dress with the vinaigrette. Toss gently so as not to break up the pear segments.

## To Serve

Place a spoonful of buttermilk cream into the bottom of each bowl. Smooth the cream around the bottoms of the bowls, then divide the salads among them. Finish the salads by grating the cheddar overtop using a microplane grater. A simple grater will also work.

# Warm Salad of Slow-Roasted Lamb

*ewe feta, sun-dried tomatoes, roasted squash purée, salted almonds, and olive vinaigrette*

*Serves 6 – 8*

## Lamb Rump

*2 Tbsp (30 mL) duck fat*
*4 lamb rumps (2 lb/1 kg), fat caps removed*
*2 Tbsp (30 mL) butter*
*5 sprigs fresh thyme*
*3 cloves garlic, crushed*
*salt and pepper to taste*

Preheat the oven to 400°F (200°C).

Add the duck fat to two medium-sized, ovenproof sauté pans. Place the pans over medium heat. Season the lamb rumps with salt and pepper and add them to the pans when the duck fat is hot and nearly smoking.

Sear the lamb rumps for about 4 minutes per side or until a golden brown colour develops. Add the butter to the pans, and cook until it begins to brown and foam. Add the thyme and garlic. Using a spoon, baste the lamb with the butter from the bottom of the pan.

Place the pans into the preheated oven. Roast for about 8 minutes. Remove the pans from the oven and put the lamb onto a plate. Pour any juices from the pan over the lamb, then let it rest for 20 minutes. Slice the lamb thinly against the grain when ready to serve.

### Meat Jus

*meat jus (from the rested lamb)*
*1¾ cup (425 mL) red wine sauce*
*1 tsp (5 mL) hazelnut oil*
*½ tsp (2 mL) sherry vinegar*
*salt to taste*

Strain the meat juices from the pan into a pot. Add the red wine sauce and bring it to a simmer. Remove from heat and add the oil and vinegar. Season with salt.

### Red Wine Sauce

*1 shallot, sliced*
*2 cloves garlic, crushed*
*1 sprig fresh thyme*
*5 black peppercorns*
*1 bay leaf*
*2 cups (500 mL) red wine*
*1 cup (250 mL) port*
*1 cup (250 mL) Madeira*
*2 cups (500 mL) demi-glace (freshly made demi-glace from a quality vendor is ideal)*

Place the shallots and garlic into a pot. Add the thyme, peppercorns, bay leaf, and red wine. Simmer until reduced by half. Add the port and Madeira. Simmer and further reduce until the total yield is approximately ¾ cups (175 mL) of liquid. Add the demi-glace and bring to a simmer. Simmer until a sauce-like consistency is achieved. Strain and set aside.

*Recipe continued on next page . . .*

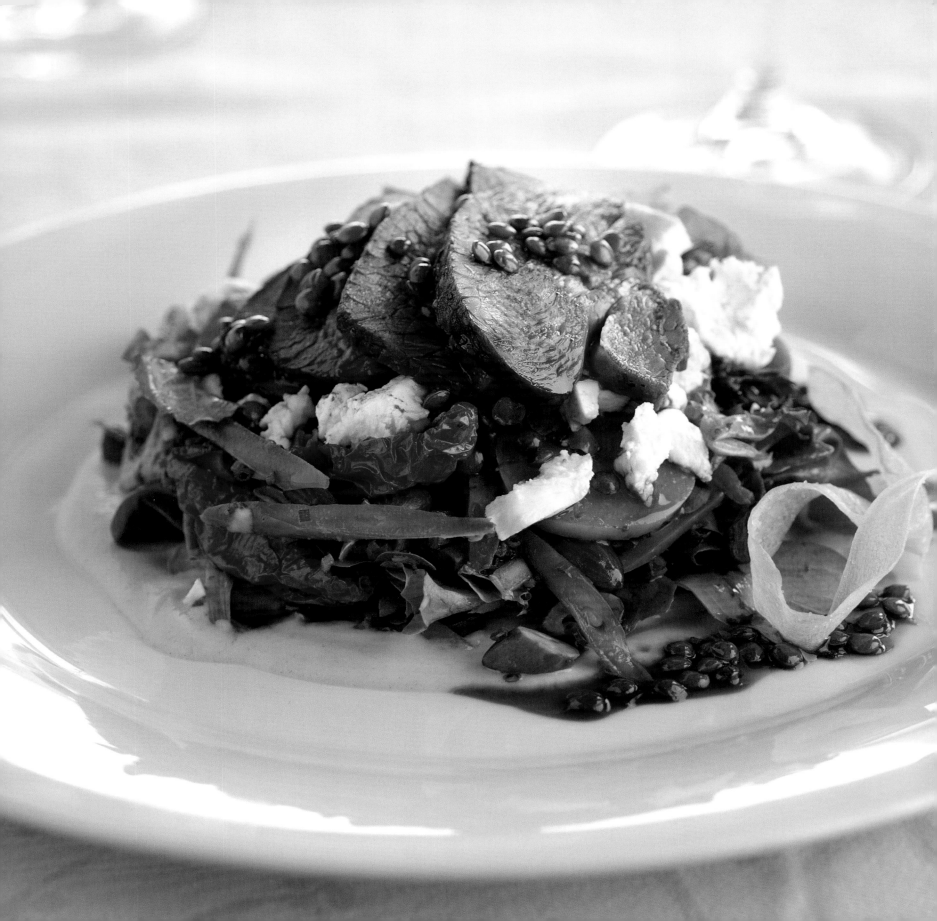

## Oven-Dried Tomatoes

*6 Roma tomatoes (slightly over-ripe), core*
*    removed and cut into halves, lengthwise*
*olive oil, as needed*
*Australian flake salt and pepper to taste*
*3 sprigs fresh rosemary*
*3 sprigs fresh thyme*

Preheat the oven to 150°F (75°C).

Place a cooling rack on top of a baking tray. Lay the tomatoes on the cooling rack, cut side up. Drizzle the tomatoes with olive oil and season with the salt and pepper as desired. Pick the leaves off the rosemary and thyme, and sprinkle them over the tomatoes. Place the tray into the preheated oven and bake for approximately 3 hours. Remove and cool. Note that the tomatoes should be dried but still retain a little moisture.

## Salad

*7 cups (2 L) mesclun greens*
*    (mixed organic)*
*⅓ cup (75 mL) shallots, finely chopped*
*⅓ cup (75 mL) chives, finely chopped*
*⅓ cup (75 mL) lentil du Puy, cooked*
*6 oven-dried tomatoes, sliced roughly*
*¼ cup (60 mL) salt roasted almonds,*
*    roughly chopped*
*¼ cup (60 mL) ewe feta, crumbled*
*2 dozen organic green beans,*
*    trimmed and cooked*
*1 dozen organic baby beets*
*    (golden and/or candy-cane varieties)*
*Olive Vinaigrette, as needed (recipe below)*
*salt and pepper to taste*

Combine the greens, shallots, chives, lentils, oven-dried tomatoes, almonds, and feta in a medium-sized mixing bowl. Warm the beans and beets in some hot water, drain well, and add to the mixing bowl. Dress lightly with olive vinaigrette and season with salt and pepper as desired.

### Olive Vinaigrette

*¼ cup (60 mL) pitted kalamata olives*
*1 oil-packed anchovy fillet*
*3 Tbsp (45 mL) red wine vinegar*
*juice of 1 freshly squeezed lemon*
*1 Tbsp (15 mL) Dijon mustard*
*½ cup (125 mL) olive oil*
*⅔ cup (150 mL) vegetable oil*
*salt and pepper to taste*

Combine all the ingredients in a blender and process until combined.

*Recipe continued on next page . . .*

## Roasted Squash Purée

*½ cup (125 mL) butter*
*1 white onion, thinly sliced*
*6 cloves garlic, thinly sliced*
*1 cinnamon stick*
*1 cup (250 mL) water*
*1 cup (250 mL) whipping cream (35%)*
*2 cups (500 mL) butternut squash,*
  *small dice*
*3 tsp (15 mL) white truffle oil*
*salt to taste*

Combine the butter, onion, garlic, cinnamon stick, and water in a medium-sized sauce pot. Cover the pot and place over medium heat. Cook the contents down until the onions are soft to the point when they fall apart. Add the cream and squash. Continue cooking until the squash begins to disintegrate. Place the mixture into a large blender and process until perfectly smooth. While the blender is running, add the truffle oil. Season and set aside.

## To Serve

Spoon some of the butternut squash purée into each bowl and then divide the salad into each bowl. Place the sliced lamb over each of the salads, then spoon some of the hot meat jus over each.

# Atlantic Lobster and Merguez Sausage-Stuffed Tortellini

*clams, fennel fondue, lobster froth, and tortellini*

*Serves 6 – 8*

## Tortellini Pasta

*1½ cups (375 mL) pasta flour (all-purpose flour may be substituted)*
*pinch of salt*
*2 tsp (10 mL) olive oil*
*1 large brown egg*
*2 egg yolks, from large brown eggs*

*For the dough*

Place the flour, salt, and olive oil in a food processor and pulse until well combined. Add the egg and egg yolks to the mixture, one at a time, pulsing the processor after each addition until the dough is fully combined. The mixture should be moist but not sticky. Remove the dough from the processor and form it into a ball, wrap in plastic wrap, and refrigerate for at least 12 hours.

*To roll the pasta dough*

Remove the dough from the fridge and microwave for 15 seconds to soften. Using a floured rolling pin, roll the dough out onto a lightly floured table until the dough can fit into a traditional pasta machine set to the maximum width. Roll the dough through the pasta machine two times on this setting, then reduce the thickness of the pasta machine in increments, until the pasta can pass easily through the machine set on #3. Fold the pasta up again, end to end, so that the folded dough can once again just fit into the machine. Repeat this process, again taking the pasta down to thickness setting #3. Cut the pasta into 3-inch (8-cm) circles using a cookie cutter or clean can. Place these discs onto a plate wrapped in plastic wrap, then cover with a second piece of wrap so they don't dry out.

Roll each disc through the pasta machine, beginning on setting #3, and work the pasta down to setting #9, the thinnest setting. The rolled-out pasta discs should be approximately 6½ inches (16 cm) in diameter. Roll out only a few discs at a time, as they have a tendency to dry out.

*To assemble the tortellini*

Lay the pasta discs on a lightly floured work surface, with a small ramekin of cool water and the tortellini filling close at hand. Spoon approximately 3 Tbsp (45 mL) of the filling into the center of each disc. Dip your finger into the water and rub a thin bead along one half of the pasta disc. Fold the other half of the disc over and pinch the edges at the top to create a half circle. From the top (the point where you joined the pasta), pinch along the open edges to seal, working the air out of the tortellini and snug against the filling. Cut the rough edge off the "half moon" using a pair of scissors. Wet one of the corners of the "half moon" with water again. Fold the dry corner over and connect it with the wet corner by pinching the two together. This will give you the shape of the tortellini. Use your fingers

*Recipe continued on next page . . .*

75

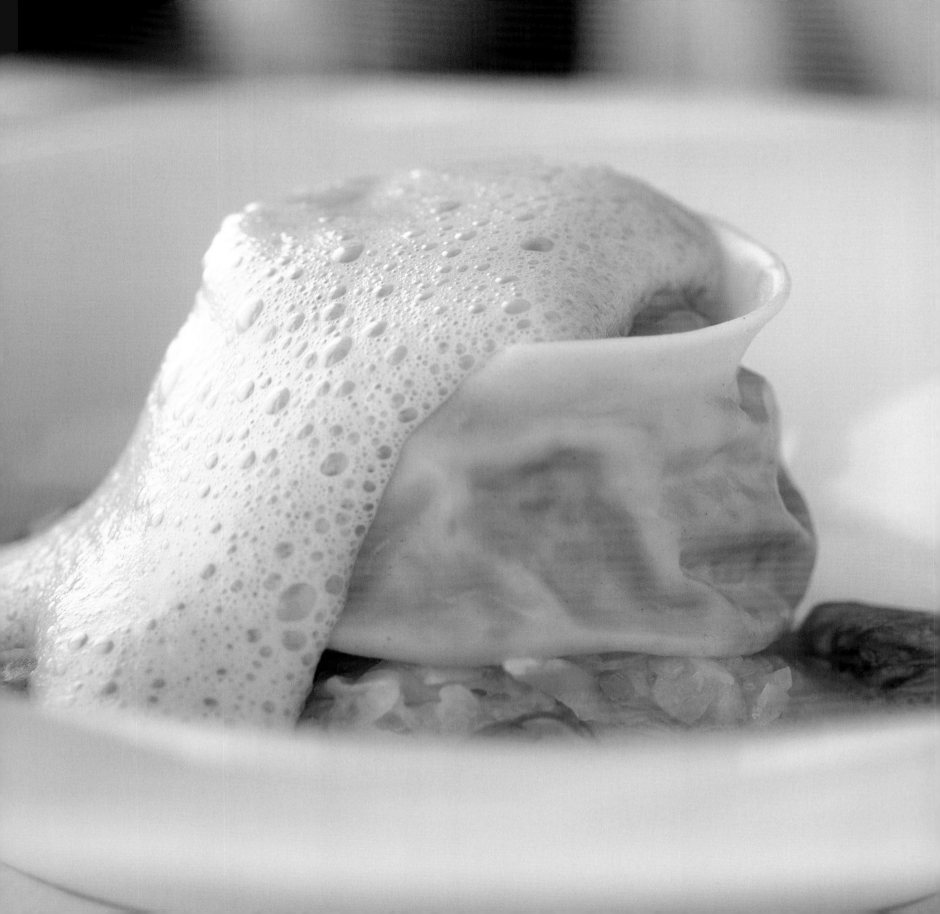

to lightly push the tortellini down, so they sit level on the table and are more symmetrical.

*To cook the tortellini*

Fill a large pot with approximately 2 inches (5 cm) of water. Bring the water to a boil. Place the tortellini in a vegetable steamer basket and place the basket in the pot (ensure that the tortellini do not sit in the water). Steam for 8 minutes.

## Lobster and Merguez Sausage Stuffing

½ lb (250 g) merguez sausages
    (approximately 4 pieces)
¼ cup (60 mL) butter
3 Tbsp + 1 tsp (50 mL) olive oil
1 white onion, finely diced
1 Tbsp (15 mL) garlic, minced
1 tsp (5 mL) smoked paprika
¼ cup (60 mL) Pernod
1 medium fennel bulb, thinly sliced
¼ cup (60 mL) bread crumbs
salt and pepper to taste
⅓ cup (75 mL) Scallop Mousse (recipe this page)
1 lobster, cooked, meat removed,
    and patted dry
⅓ cup (75 mL) chives, finely chopped
½ bunch flat leaf parsley, washed, dried,
    and finely chopped

Grill the sausages until fully cooked, and set aside. Combine the butter, olive oil, white onion, garlic, and Pernod in a medium-sized pot. Cover and cook over medium heat until the onions are soft. Add the sliced fennel and cook until soft. Add the sausages and put the mixture into a food processor. Pulse the mixture until uniform but not smooth. Add the bread crumbs and pulse again in the processor. Season with salt and pepper. Allow the mixture to cool to room temperature, then gently mix in the lobster, chives, scallop mousse, and chopped parsley until well combined.

## Scallop Mousse

¼ lb (125 g) scallops, cleaned, patted dry,
    and chilled on ice
pinch of salt
⅔ cup (150 mL) whipping cream (35%),
    chilled on ice

Place the scallops in a food processor. Process until the scallops are smooth, then add the salt. Slowly drizzle the whipping cream into the mixture while the machine is running. Place in the fridge.

## Fennel Fondue

¼ cup (60 mL) butter
3 Tbsp + 1 tsp (50 mL) olive oil
3 shallots, finely diced
2 fennel bulbs, thinly sliced
3 Tbsp + 1 tsp (50 mL) Noilly Prat
3 Tbsp + 1 tsp (50 mL) Pernod
juice of 2 freshly squeezed lemons

Combine all the ingredients, except the lemon juice, in a medium-sized pan. Place the pan over medium heat. Cook the mixture down slowly, until the fennel can be crushed easily and is soft throughout. Finish with the lemon juice and adjust the seasoning as desired.

*Recipe continued on next page . . .*

## Clams

*2 lb (1 kg) clams*
*½ cup (125 mL) Noilly Prat*
*½ cup (125 mL) Pernod*

Place a large pot over high heat. Meanwhile, rinse the clams under cold water and discard any open shells. Prepare a bowl with ice and water (this will be used to cool the cooked clams). When the pan is hot, place the clams inside, add both liquids, and cover with the lid. When the shells open, remove the pot from the heat, place the clams in a bowl, and set the bowl atop the ice bath. Remove the meat from the shells as they cool. Strain the cooking liquid over the cooled clam meat and put in the fridge.

## Lobster Froth

*½ cup (125 mL) clam liqueur*
*1¼ cup (310 mL) lobster bisque (freshly*
*    made lobster bisque from a quality vendor*
*    is ideal)*
*¾ cup + 2 Tbsp (205 mL) whipping cream (35%)*
*juice of 1 freshly squeezed lemon*
*½ cup (125 mL) basil leaves*

Combine the clam liqueur, lobster bisque, and whipping cream in a medium-sized sauce pot. Place the pot over medium heat. Simmer the mixture until well combined. Add the lemon juice and basil, and remove from heat. Allow to "steep" for 10 minutes. Strain into another medium-sized sauce pot, adjust the seasoning as desired, and set aside.

## To Serve

Place a small amount of fennel fondue into each bowl, then divide the clams among each bowl. Place a tortellini into each bowl on top of the fennel fondue. Place a hand-held blender into the pot of lobster froth so the blender attachment just barely skims the surface of the sauce. Carefully pulse the blender up and down into the sauce so that air is incorporated. You want to generate as much froth and bubbles as possible. Once a thick froth has developed, scoop it over the tortellini to cover.

# Côte de Boeuf

*handmade chips, Béarnaise sauce, button onions, and watercress*

*Serves 6 – 8*

## Beef Rib-Eye

*4 rib-eye steaks (each about 2 inches/*
  *5 cm thick)*
*2 Tbsp (30 mL) duck fat*
*4 Tbsp (60 mL) butter*
*salt and pepper to taste*

Heat two 12-inch (30-cm) cast iron pans on high heat until smoking. Season the steak well with salt and pepper. Place the duck fat into the heated pans and swirl to evenly coat. Place two steaks in each pan and sear until the bottom side is dark brown, about 5 minutes. Flip the steaks and cook another 4 minutes. Add the butter and cook until it foams. Remove the pans from the heat but leave the meat inside the pans for another 2 minutes. Remove the meat and pour the pan juices overtop. Allow the steaks to rest for 10 to 15 minutes.

There are three distinct sections to each of the rib-eye steaks. Remove the end bit and the curved piece that covers the eye of the steak (the "foot"). Trim the thin layer of sinew off these two pieces and cut them so that they end up symmetrical. For the "eye" of the steak, trim around the outside to remove any excess fat and sinew, then cut widthwise into 6 thin slices. Divide the pieces equally to serve.

## Meat Jus

*meat jus (from cooking the steak)*
*1⅔ cup (400 mL) red wine sauce*
*1 tsp (5 mL) hazelnut oil*
*½ tsp (2 mL) sherry vinegar*
*salt to taste*

Strain the meat juices from the resting steaks into a pot. Add the red wine sauce and bring to a simmer. Remove from the heat and add the oil and vinegar. Season with salt.

## Red Wine Sauce

*1 shallot, sliced*
*2 cloves garlic, crushed*
*1 sprig fresh thyme*
*5 black peppercorns*
*1 bay leaf*
*2 cups (500 mL) red wine*
*1 cup (250 mL) port*
*1 cup (250 mL) Madeira*
*2 cups (500 mL) demi-glace (freshly made*
  *demi-glace from a quality vendor is ideal)*

Combine the shallots and garlic in a pot. Add the thyme, peppercorns, bay leaf, and red wine. Simmer the mixture until reduced by half. Add the port and Madeira. Reduce until the total yield is approximately ¾ cup + 2 Tbsp (200 mL) of liquid. Add the demi-glace and slowly simmer until a sauce-like consistency is achieved. Strain and set aside.

*Recipe continued on next page . . .*

*. . . Côte de Boeuf continued*

## Button Onions

*1 Tbsp (15 mL) duck fat*
*2 cups (500 mL) pearl onions*
*(peeled and frozen)*
*½ cup (125 mL) butter*
*1½ cups (375 mL) dark chicken stock*
*salt and pepper to taste*

Preheat the oven to 350°F (180°C). Place an ovenproof frying pan over medium-high heat. When the pan is hot, add the duck fat. Allow the duck fat to melt and lightly smoke, then add the onions. Sauté the onions until they achieve an even golden-brown colour. Add 1 Tbsp (15 mL) butter to encourage more colour on the onions. Add the chicken stock. When the stock has boiled, place the pan in the oven, stirring occasionally. When the onions are soft, remove the pan from the oven. Place the pan over high heat, and reduce the liquid until a glaze has formed. Add the remaining butter in small pieces (this allows the butter to emulsify into the glaze). Taste and adjust the seasoning with salt and pepper. Remove the onions and excess glaze from the pan. Serve immediately or cool and reheat when ready.

## Béarnaise Sauce

*6 egg yolks*
*3 Tbsp (45 mL) water*
*⅓ cup (75 mL) Béarnaise Reduction*
*(recipe below)*
*salt to taste*
*2 cups (500 mL) butter, melted*
*juice of 1 freshly squeezed lemon*
*1 Tbsp (15 mL) chopped fresh tarragon*

Fill a medium-sized pot with water and place over medium heat until simmering. In a metal bowl combine the egg yolks, water, Béarnaise reduction, and salt. Place the bowl over the pot of simmering water and whisk until it doubles in volume and becomes glossy in appearance. Remove from the heat and continue to whisk while slowly pouring in the melted butter. Taste and adjust with lemon juice and salt. The sauce should be thick and fluffy. Add chopped tarragon and stir through. Serve immediately.

### Béarnaise Reduction

*2 shallots, chopped*
*1 garlic clove, sliced*
*1 bay leaf*
*5 black peppercorns*
*½ cup (125 mL) whole fresh tarragon*
*⅓ cup (75 mL) tarragon vinegar*
*⅓ cup (75 mL) white wine*

Combine all the ingredients in a medium-sized pot, bring to a boil, and reduce by half. Strain and cool.

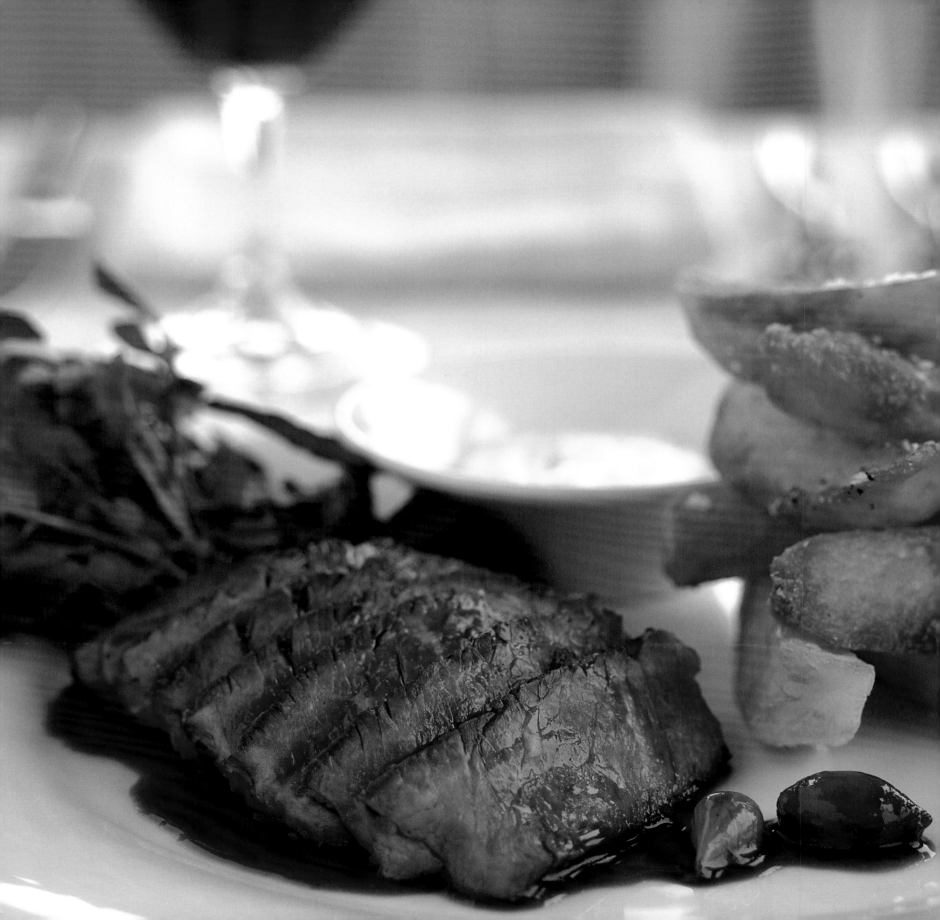

## Handmade Chips

*vegetable oil for deep-frying*
*pinch of salt*
*8 medium-sized russet potatoes*
*Australian flake salt and pepper to taste*

Place the vegetable oil in a deep pot and heat to 325°F (160°C). Fill another pot with water, add a pinch of salt, and bring to a boil. Peel the potatoes and cut lengthwise into 3 pieces. Cut each piece lengthwise again, creating 3 chips per slice (9 chips per potato). Add the potatoes to the boiling, salted water and simmer until the potatoes are 85 percent cooked. Remove from the water carefully and allow to dry on a towel. Blanch the potatoes in small batches in the hot oil until they're a light golden colour. Remove, drain, and cool. This portion of the procedure can be done well in advance.

Heat the oil to 360°F (185°C) and fry the chips again until they become a deep golden-brown. Remove from the oil, and place on a sheet pan lined with paper towel and season with salt and pepper. Serve immediately.

## Spinach

*½ cup (125 mL) butter*
*2 tsp (10 mL) chopped garlic*
*4 cups (1 L) baby spinach, washed and dried*
*pinch fresh grated nutmeg*
*pinch salt and pepper*

In a large saucepan, melt the butter over medium-low heat. Add the garlic and cook briefly. Add the spinach, nutmeg, and salt and pepper. Cook until the spinach has wilted. Remove from the heat, drain, and pat dry with a kitchen towel. Reheat in the microwave when ready to serve.

## Garnish

*8 small bunches of watercress, cleaned and*
*dried, stems removed*

## To Serve

Place one portion of rib-eye onto each plate. Divide the chips, spinach, and watercress between each plate. Add some of the button onions to the meat jus, bring back to a simmer, and then spoon over the steak on each plate. Serve the Béarnaise Reduction in a ramekin on the side.

# Pan-Fried Halibut

*honey mussels, saffron cream, new potatoes, and basil mayonnaise*

*Serves 6 – 8*

### Halibut

*3 Tbsp (45 mL) olive oil*
*eight 6-oz (175-g) premium halibut fillets*
  *(centre cut)*
*salt and pepper to taste*
*2 Tbsp (30 mL) butter*
*juice of 1 freshly squeezed lemon*

Preheat the oven to 350°F (180°C).

Divide the olive oil between two medium-sized, ovenproof sauté pans over medium heat. Heat the oil until it begins to smoke. Generously season the halibut fillets with salt and pepper. Add the fillets to the pan, placing the most presentable side of the fillet down first.

Sear the fish for approximately 3 minutes on the one side, or until a golden-brown colour has developed. Place the pans into the preheated oven for about 4 minutes. Remove the pans from the oven and add the butter. Using a spoon, baste the fish with the foaming butter. Squeeze with fresh lemon and serve.

### Honey Mussels

*1 lb (500 g) honey mussels, cleaned*
  *(approximately 24 mussels)*
*3 Tbsp (45 mL) Pernod*
*⅓ cup + 2 Tbsp (105 mL) Noilly Prat*

Combine all the ingredients in a very hot sauté pan. Cover with a lid and steam until the shells have opened. Discard any unopened mussels. Remove the cooked mussels from the liqueur and place them in a bowl set over ice water. Remove the meat from the mussels as they cool. Set aside 3 Tbsp of the liqueur and strain the rest of the cooled liqueur over the cleaned mussels.

### Saffron Cream

*3 Tbsp (45 mL) Pernod*
*3 Tbsp (45 mL) Noilly Prat*
*3 Tbsp (45 mL) mussel liqueur*
*¼ tsp (1 mL) saffron (approximately 6 threads)*
*⅓ cup + 2 Tbsp (105 mL) lobster bisque (freshly*
  *made bisque from a quality vendor is ideal)*
*⅓ cup + 2 Tbsp (105 mL) whipping cream (35%)*
*½ cup (125 mL) butter, chilled and cubed*
*juice of 1 freshly squeezed lemon*
*salt and pepper to taste*
*2 Tbsp (30 mL) chives, chopped finely*
  *(for garnish)*

Combine the Pernod, Noilly Prat, mussel liqueur, and saffron in a medium-sized sauce pot over medium heat. Simmer until the volume is reduced by half. Add the lobster bisque and whipping cream. Bring to a boil. Remove the sauce from the heat and immediately add the butter, swirling it into the sauce. Finish with lemon and salt and pepper. Garnish with chives.

*Recipe continued on next page . . .*

*. . . Pan-Fried Halibut continued*

## Basil Mayonnaise

*2 egg yolks, from large brown eggs*
*2 Tbsp (30 mL) Dijon mustard*
*4 cloves garlic, minced*
*1 tsp (5 mL) Xeres vinegar*
*juice of 1 freshly squeezed lemon*
*pinch cayenne pepper*
*⅓ cup + 2 Tbsp (105 mL) olive oil*
*1⅔ cups (400 mL) vegetable oil*
*2 Tbsp (30 mL) Basil Purée (recipe below)*
*salt and pepper to taste*

Combine the egg yolks, Dijon mustard, garlic, vinegar, lemon juice, and cayenne pepper in a deep narrow bowl. Using a stick blender, slowly add both oils in a thin stream while pulsing the blender. The mixture should emulsify and become the consistency of mayonnaise. Add the remaining ingredients and blend until uniform.

### Basil Purée

*3 cups (750 mL) basil leaves*
*⅓ cup (75 mL) olive oil*

Drop the basil leaves into a pot of boiling water for about 10 seconds. Remove and immediately drop the cooked basil into ice water. Allow to cool for several seconds, then remove and pat dry with paper towel. Place the blanched basil into a blender, add the oil, and blend until smooth.

## Spinach

recipe page 82

## Tomato Concasse

*5 medium-sized Roma tomatoes (slightly underripe),*
*   blanched, peeled, and seeded*
*⅓ cup (75 mL) olive oil*
*1 tsp (5 mL) balsamic reduction*
*5 basil leaves*
*Australian flake salt and pepper to taste*

Dice the tomato fillets and place them in a small mixing bowl. Add the olive oil and balsamic reduction. Slice the basil leaves thinly and combine with the tomato mixture. Season with salt and pepper as desired.

## Baby Carrots and New Potatoes

*8 new potatoes (white)*
*16 organic baby carrots (mixed colours, if available)*

Use good quality, fresh organic vegetables. Bring the white new potatoes to a simmer in a medium-sized sauce pot of cold, salted water. When the potatoes are tender, allow them to cool slightly in the cooking liquid, then remove and gently peel away the skins with a small knife. Peel the baby carrots with a vegetable peeler, then simmer until tender.

## To Serve

Divide the spinach and carrots between the plates. Toss the warm potatoes in the basil mayonnaise and rest on the spinach. Warm the honey mussels through in the saffron sauce and finish with chopped chives. Place a piece of halibut onto each plate and then spoon the saffron sauce over the fish. Finish by spooning the tomato concasse over the top of the fish.

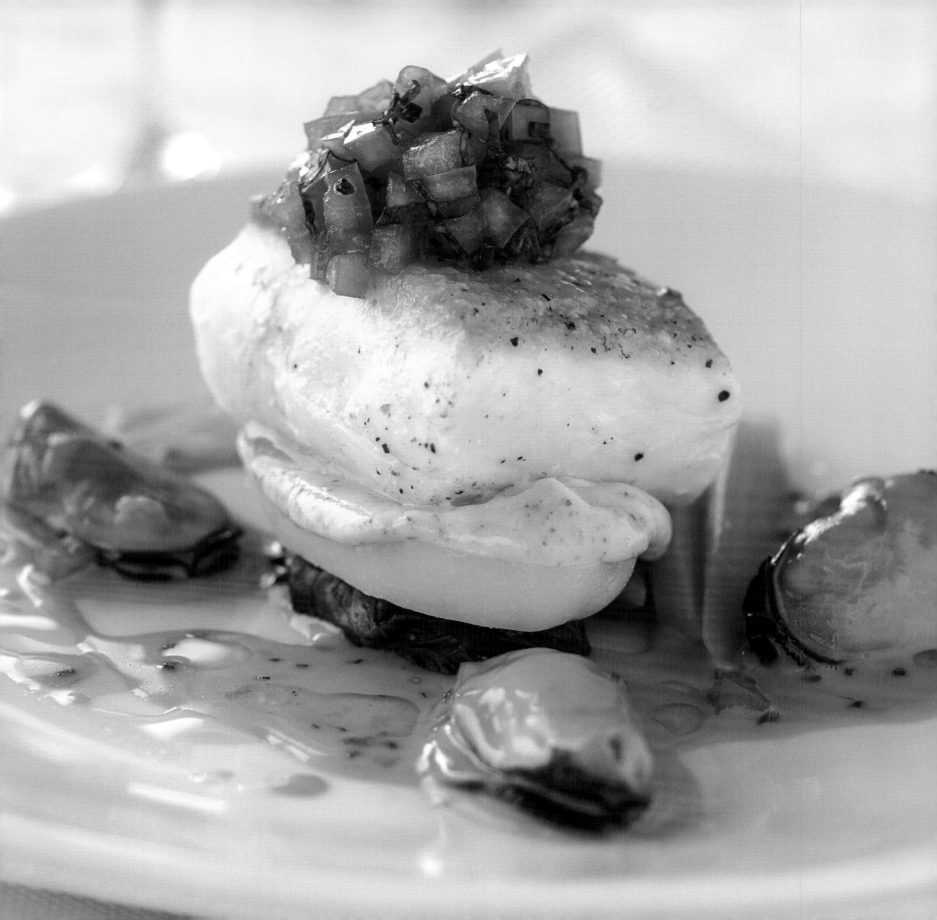

# Sticky Toffee Pudding

*vanilla bean ice cream*

*Serves 6 – 8*

## Ice Cream

*1 cup (250 mL) homogenized milk*
*1 cup (250 mL) whipping cream (35%)*
*1 vanilla bean, split and scraped*
*6 egg yolks, from large brown eggs*
*½ cup (125 mL) sugar*

Begin by setting aside 2 medium-sized mixing bowls, one set with ice, and the other with a fine mesh strainer. Combine the milk, cream, vanilla beans, and pod and bring to a boil. Remove from the heat. Whisk the egg yolks and sugar in a bowl to blend. Add the milk mixture into the yolk mixture and stir. Return this mixture to pan and cook over low heat, stirring constantly with a wooden spoon, until the custard thickens (about 5 minutes). Draw your finger over the back of the spoon. When the line holds, the custard is ready. Strain the custard into the bowl with the mesh, remove the vanilla pod, and place the bowl over the ice bath to cool rapidly. Once cold, pour the mixture into an ice cream machine and follow the manufacturer's directions.

## Toffee Sauce

*1 cup (250 mL) butter*
*1 cup (250 mL) brown sugar*
*1 cup (250 mL) whipping cream (35%)*
*¼ cup (60 mL) fancy molasses*
*juice of 1 freshly squeezed lemon wedge*

Combine the butter, sugar, and whipping cream in a pot. Boil for 5 to 10 minutes to thicken. Remove from the heat and stir in the molasses and lemon juice.

*Recipe continued on next page . . .*

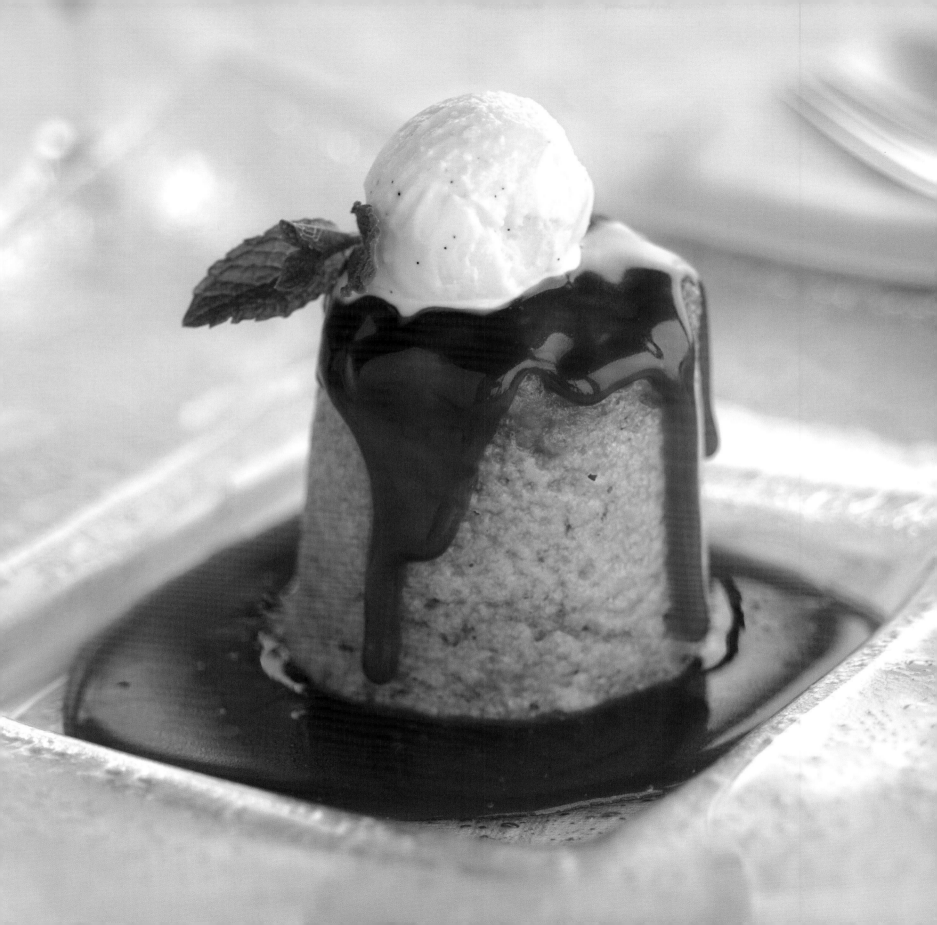

## Pudding Cake

½ cup (125 mL) dates
2 cups (500 mL) all-purpose sifted flour
1 tsp (5 mL) baking powder
5 egg whites, from medium brown eggs
½ cup (125 mL) butter
½ cup (125 mL) brown sugar
5 egg yolks, from medium brown eggs
Toffee Sauce (recipe page 84)

Preheat the oven to 350°F (180°C).

Dice the dates and boil them in water for 5 to 10 minutes, or until soft. Drain, squeeze out the moisture, and set the dates aside.

Place the flour and baking powder into a bowl, stir, and set aside. Whisk the egg whites until firm and set aside. Cream the butter and sugar with an electric mixer until light and creamy. Add the yolks and blend. Add the flour and mix slowly until just combined. Fold in the egg whites and the dates until combined. The mixture should be airy but free from heavy lumps.

Pre-grease six ½-cup (125-mL) ramekins and dust with flour. Place 1 Tbsp (15 mL) of toffee sauce into the bottom of each mold. Fill the molds ¾ high with the cake dough. Place in a deep baking tray and pour hot water into the baking tray ¼ way up the sides of the ramekins. Cover the tray with tin foil and place in the preheated oven. Bake for 25 to 35 minutes. Place a toothpick into the middle of one cake to test. If the toothpick comes out clean, the cakes are ready. Cool until ready to serve.

## To Serve

This recipe can be made up to this point one day ahead.

Reheat the toffee sauce. To reheat the cakes, remove them from the molds by tapping them upside down—they should release easily. Place into a steamer or microwave until hot. Place a cake on a plate, pour the toffee sauce over top, and serve with a small scoop of ice cream.

# Summer Berries with Balinese Pepper and Wild Mountain Honey

*muscat wine granité, glace au lait, and almond shortbread*

Serves 6 – 8

## Summer Berries

1½ cups (375 mL) organic red raspberries
1½ cups (375 mL) organic golden raspberries
1½ cups (375 mL) organic blueberries
1½ cups (375 mL) organic strawberries, stems
    removed, and quartered
fresh ground Balinese pepper (you may
    substitute regular black pepper)
wild mountain honey (you may substitute
    your favourite organic honey)

Combine all the berries in a medium-sized mixing bowl. Season to taste with freshly ground pepper and enough honey to evenly coat the berries. Mix gently until all the ingredients are evenly distributed.

## Muscat Wine Granité

½ cup (125 mL) muscat wine
½ cup (125 mL) mineral water

Combine the muscat wine with the water in a shallow pan. Place the pan in the freezer. Stir occasionally and freeze until solid granules form (between 6 to 12 hours).

## Glace au Lait

1 cup (250 mL) homogenized milk
2 egg yolks, from large brown eggs
¼ cup (60 mL) sugar

Place the milk in a pan and bring to a boil. In a bowl, whisk together the yolks and sugar. Slowly pour the hot milk into the egg mixture. Return this mixture to the pan and continue to cook over low heat, stirring constantly with a wooden spoon. After 5 minutes, the mixture should thicken until it evenly coats the back of your wooden spoon. Strain, cool, and place into an ice cream machine until frozen.

*Recipe continued on next page . . .*

## Shortbread

*½ cup + 3 Tbsp (170 mL) butter,*
*room temperature*
*1 small brown egg*
*½ cup + 1 Tbsp (140 mL) icing sugar, sifted*
*⅓ cup (75 mL) ground almonds*
*pinch of salt*
*1½ cups + 2 Tbsp (405 mL) all-purpose flour,*
*sifted*

Preheat the oven to 325°F (160°C).

Combine the butter and egg. Combine the remaining ingredients in a separate bowl and mix until the dough comes together. Be careful not to overmix. Roll into 2 discs, cover with plastic wrap, and set in the fridge for 4 hours. Roll out between two sheets of parchment paper or on a floured wooden board until ½ inch (1 cm) thick. Cut out round discs with a cookie cutter and sprinkle with granulated sugar. Place on a cookie sheet and bake in the preheated oven for 17 minutes. Cool at room temperature.

## To Serve

Place the berries in a martini glass. Add a small even layer of muscat wine granité on top and place one small scoop of glace au lait on top of the granité. Serve the shortbread on the side.

# Delice of Chocolate

*warm chocolate coulant, chocolate peanut brownie, peanut butter ice cream, chocolate and hazelnut mousse with griottine cherries*

*Serves 6 – 8*

## Coulant

*½ cup (125 mL) butter*
*5 oz (150 g) dark chocolate*
*3 egg yolks, from large brown eggs*
*3 large brown eggs*
*3 Tbsp (45 mL) sugar*
*¼ heaping cup all-purpose flour, sifted*
*icing sugar, as needed*

Melt the butter over a double boiler, add the chocolate to melt, and stir to combine. Remove from the heat. Whisk the eggs and sugar together in a separate bowl. Add the hot mixture to the egg mixture and stir. Add the flour and combine. Cool completely for about 2 hours. Line ring molds or ramekins with butter and dust with flour. If using ring molds, place the floured molds on top of parchment paper. Using a piping bag, fill the molds or ramekins approximately half way up with the coulant batter. Refrigerate until ready to serve.

## Brownie

*½ cup (125 mL) butter*
*2¼ oz (63 g) dark chocolate*
*½ cup (125 mL) sugar*
*pinch cocoa powder*
*½ cup (125 mL) all-purpose flour, sifted*
*pinch baking soda*
*¾ cup + 1 Tbsp (190 mL) almond powder*
*½ cup (125 mL) pecans, roughly chopped*
*2 large brown eggs*

Preheat the oven to 325°F (160°C).

In a double boiler, melt the butter and add the chocolate, stirring until melted. Add the sugar and remove the boiler from the heat. In a separate bowl, combine the melted mixture with the remaining ingredients. Line an 8-inch (20-cm) square baking tray with parchment paper, then spoon in the batter. Smooth the dough out to ½-inch (1-cm) thickness using a spatula. Bake in the preheated oven for 45 minutes. Remove from the oven and cool in the fridge for 2 to 4 hours, in which time the brownie will continue to set.

*Recipe continued on next page . . .*

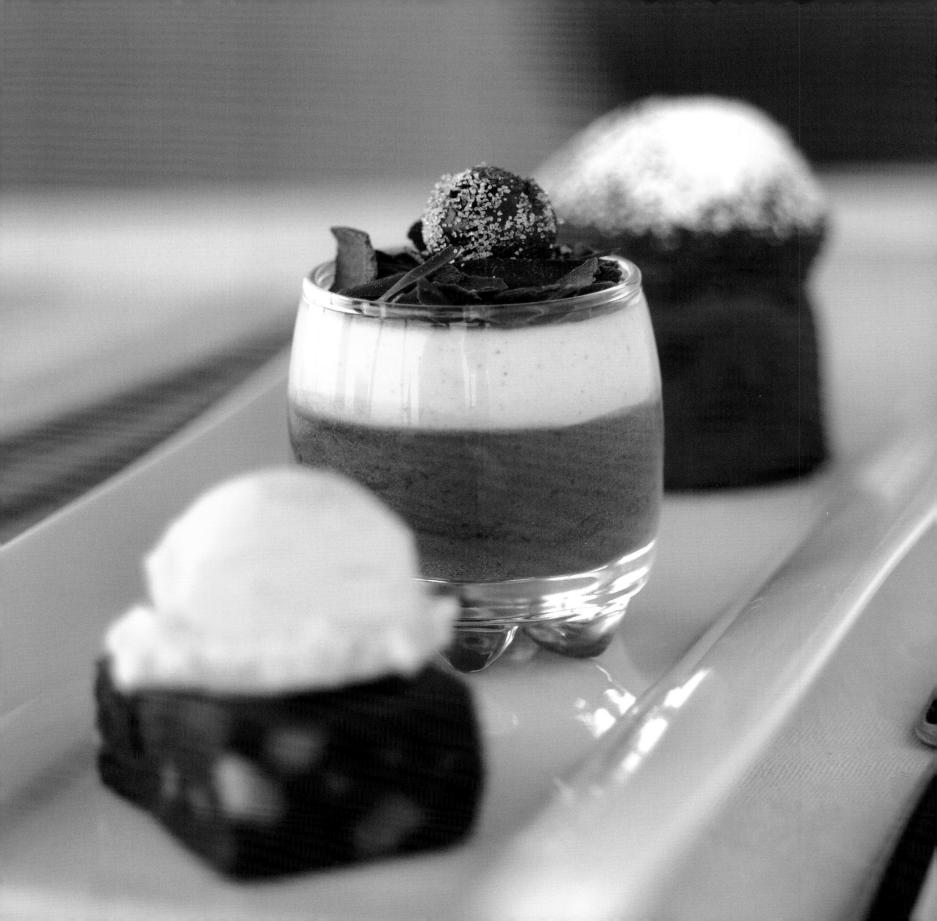

. . . *Delice of Chocolate continued*

## Ganache

*3 Tbsp + 1 tsp (50 mL) whipping cream (35%)*
*dash glucose syrup (optional)*
*2½ oz (70 g) dark chocolate*

Boil the whipping cream and glucose in a double boiler. When the cream has boiled, add the chocolate and stir constantly until completely dissolved. Slightly cool the ganache, pour it over the brownie, and smooth it out with a spatula.

## Peanut Butter Ice Cream

*1 cup (250 mL) homogenized milk*
*1 cup (250 mL) whipping cream (35%)*
*1 vanilla bean, split and scraped*
*6 egg yolks, from large brown eggs*
*½ cup (125 mL) sugar*
*½ cup (125 mL) smooth peanut butter*
*dash tremoline sugar (optional)*

Begin by setting aside 2 medium-sized mixing bowls, one set with ice and the other with a fine mesh strainer. Combine the milk, cream, vanilla beans, and seeds and bring to a boil. Remove from the heat. Whisk the egg yolks and sugar in a bowl to blend. Add the milk mixture to the eggs and stir. Return the mixture to the pan and cook over low heat, stirring constantly with a wooden spoon until the custard thickens, about 5 minutes. Draw your finger over the back of the spoon. When the line holds, the custard is ready. Strain the custard into the prepared bowl with the strainer, remove the vanilla pod, and place the bowl over the ice bath to cool rapidly. Whisk the peanut butter into the mixture (while it's still warm) until smooth. Once chilled, pour the mixture into an ice cream machine and follow the manufacturer's directions.

## The Mousses

Prepare six 2-oz (60-mL) shot glasses by dropping 1 Tbsp (15 mL) of either griottine juice or cherry brandy into the bottom of each glass. Make one mousse at a time in the order that they appear below.

*Chocolate Mousse*

*½ cup (125 mL) whipping cream (35%)*
*2 egg whites, from large brown eggs*
*3 tsp (15 mL) sugar*
*5 oz (150 g) dark chocolate*
*1 Tbsp (15 mL) butter*
*1 egg yolk, from a large brown egg*
*1 Tbsp (15 mL) brandy*
*griottine cherries*
*chocolate shavings*

Whip the cream until you have firm peaks, then set it aside in the fridge. In a separate bowl, whisk the egg whites until firm, add the sugar, and set aside. Melt the chocolate over a double boiler, add the butter, and stir to combine. Remove from the heat and stir in the egg yolk. Working quickly, spoon the chocolate mixture into a bowl and fold in the egg whites. Fold in the whipped cream and place the mixture into a piping bag. Immediately pipe half way up two 1-oz glasses and tap the glasses to smooth out the mousse. Place the glasses in the fridge.

*Praline Mousse*

*1¾ cups (425 mL) whipping cream*
*1 sheet of gelatin*
*¼ cup + 1 tsp (65 mL) homogenized milk*
*1 egg yolk, from a large brown egg*
*3 Tbsp (45 mL) sugar*
*3 Tbsp (45 mL) praline paste*

Whip 1 cup (250 mL) of the whipping cream until firm and set aside in the fridge. Place the gelatin into cold water to soften. Combine the milk with the remaining cream and bring to a boil. Remove from the heat. Whisk the yolk and sugar in a bowl until combined. Add the milk/cream mixture into the egg/sugar mixture and stir. Return the mixture to the pan and cook over low heat, stirring constantly with a wooden spoon until the custard thickens, about 5 minutes. Draw your finger over the back of the spoon. When the line holds, the custard is ready. Strain into a bowl. Place the ingredients into a blender, add the praline paste, and squeeze out the water from the gelatin into the blender. Blend and strain into a bowl. Fold the reserved whipped cream into the mix and place into a piping bag. The mixture will be quite loose as you pipe it into the two 1-oz glasses over the chocolate mousse. Cool in the fridge for 2 hours until set.

## To Serve

To assemble the complete dish, heat the oven to 450°F (230°C). Place the coulants into the oven for 7 to 10 minutes. Meanwhile, assemble the plates by placing a small square of brownie in the middle of the plate, followed by a small scoop of peanut butter ice cream placed directly on top of the brownie. Place the mousse glasses onto the plates and garnish with chocolate shavings. Roll one griottine cherry in sugar and place on top of the chocolate shavings. Remove the coulants from the oven. The outside should be cooked, but the inside should be warm and liquid. Remove the coulants from their ring molds, or if you used ramekins, leave the coulants inside, then dust with icing sugar.

# Photo credits*

*All photographs and recipes appear courtesy of Grouse Mountain Resorts Ltd.*

Gaetano Fasciana 1, 11, 13, 14, 24, 30, 31, 32, 33, 34–35, 37, 38, 39, 40, 41, 42–43, 46, 47, 48, 49, 50–51, 52–53, 54, 55, 56, 57, 62–63, 67

Olaf Strassner 3, 12, 17

Stefan Schulhof 6–7

John Sinal 10, 18, 20, 23, 26, 28, 61

Johnny Lyall 15

Jon Cartwright 16

Nicci Gore-Langton 22, 36, 44, 45

John McQuarrie 29

Tom Ryan 60

# Recipe credits

*Text on page 66 by Envisioning + Storytelling. All food photography (68–95) by Shawn Taylor.*

Anthony L. Sedlak
  Warm Salad of Slow Roasted Lamb
  Atlantic Lobster and Merguez Sausage-
    Stuffed Tortellini
  Côte de Boeuf
  Pan-Fried Halibut
  Poached Bosc Pear and Aged
    Cheddar Salad

Tobin Boothe
  Delice of Chocolate
  Sticky Toffee Pudding
  Summer Berries with Balinese Pepper
    and Wild Mountain Honey